HIDDEN
HISTORY
of the
IRISH *of*
NEW JERSEY

HIDDEN HISTORY

of the

IRISH *of*
NEW JERSEY

TOM FOX

THE
History
PRESS

Published by The History Press
Charleston, SC 29403
www.historypress.net

Cover images: Billy Briggs. *Courtesy of the David Gard Collection*. John Holland. *Courtesy of the Paterson Museum*.

First published 2011

Manufactured in the United States

ISBN 978.1.60949.030.0

Library of Congress Cataloging-in-Publication Data

Fox, Thomas, 1947-
Hidden history of the Irish of New Jersey / Tom Fox.
p. cm.
ISBN 978-1-60949-030-0
1. Irish--New Jersey--History. 2. Irish--New Jersey--Biography. 3. Irish Americans--New Jersey--History. 4. Irish Americans--New Jersey--Biography. 5. New Jersey--Emigration and immigration--History. 6. Ireland--Emigration and immigration--History. I. Title.
F145.I6F69 2011
305.891'620730749--dc22
2010050117

Notice: The information in this book is true and complete to the best of our knowledge. It is offered without guarantee on the part of the author or The History Press. The author and The History Press disclaim all liability in connection with the use of this book.

For Nancy Kero
Queen of the Slipstream

CONTENTS

Contents

ACKNOWLEDGEMENTS

No one can set out to write about the Irish in the Garden State without the advice, assistance and friendship of Charlie Laverty, Joe Bilby and Jim Lowney, and I have been blessed with all three for many years. John Cunningham has been an unknown mentor for fifty years, while Angela Carter's love of Irish literature and history has spurred on me and hundreds of others throughout the tri-state area. It should surprise nobody in New Jersey that there are innumerable librarians, amateur researchers and committed lovers of local Jersey lore whose kindness has advanced this story and many others. The remarkable Frank Setlock has been a giving and forgiving friend and technical expert, and Connor and Ryan Dudas have been formidable research assistants. Dave Wilson and Anna McHugh have also been gracious with their time on my behalf, but all errors emanating from the stray bog are mine alone.

INTRODUCTION

More than half the people born in Ireland between 1815 and 1915 died somewhere other than their homeland. Where the Irish went, how they arrived at their destinations and what they found upon arrival has become a genre all its own. The number of souls leaving Ireland in those hundred years was astounding, the count forever unprovable, but few experts would argue that more than four million may have fled the tiny Emerald Isle.

Thousands perished before even landing on a foreign shore, in vessels referred to by descendants as "coffin ships," eerily resembling British slave ships of an earlier century. Seventeen thousand Irish alone died at sea in 1847, en route to North America, their dreams and stories lost forever in the cold Atlantic.

Untold more died within a decade of stepping ashore, a great percentage perishing of poverty-driven disease contracted while building canals and railroads, including twenty thousand who died digging the New Basin Canal in New Orleans, many of whom were buried where they dropped. Others died on contamination islands like Grosse Isle in the St. Lawrence River, buried in mass graves.

Perhaps the most difficult to enumerate were those Irish who perished through ethnic hate or greed. One story of the Irish in Maine is sadly symptomatic of many tales throughout several continents. Though there has been an Irish presence in Maine since colonial times, a surge in 1832 saw the Irish taking advantage of the cheaper British fares, sailing to Canadian ports and then working their way south to Maine via small boats or by foot. Maine

officials, desperately fearing cholera, as well as a huge influx of undesirables, tried to seal their interior borders. The state militia threw out skirmish lines and turned away unknown hundreds in the woods, causing hundreds (if not thousands) of immigrants, who had already suffered displacement and a winter sea voyage, to become lost in the vast Maine wilderness, a certain and most cruel death sentence.

Nonetheless, those lucky and tough enough to make a new life outside Ireland saw their progeny multiply worldwide beyond any human or scientific estimates. Today, there are strong Irish population groups from Argentina to Australia and from San Diego to Newfoundland.

In the United States alone, it is estimated that at least two million Irish emigrated between 1815 and 1915. Hundreds of Irish stories have been lovingly and honestly recorded. It is possible to find throughout the country such diverse titles as *Minnesota's Irish*, *The Irish Texans* and *The Butte Irish*, as well as the more predictable *The Irish in Boston*, *The Irish in America* and *The New York Irish*. Indeed, diaspora stories are now legendary, but until 2004, not one pamphlet, dissertation or book had tried to tell the history of the Irish in New Jersey.

It is difficult to fathom how New Jersey has been shortchanged—or shortchanged itself—in the telling of its own Irish-American history, particularly in light of the fact that there has been an Irish presence in the Garden State since the mid-1600s. New Jersey is the most densely populated state in America, and 40 percent of its residents claim some Irish ancestry. In addition, New Jersey sits between the two most common ports of Irish arrivals for centuries—Philadelphia and New York. The state mirrors the population of pre-famine Ireland, with over eight million people in just eighty-seven hundred square miles, about one-third the size of Ireland.

In many respects, however, the Garden State has always been possessed of an identity crisis, a crisis that has nothing to do with the Irish. New Jersey has always been the proverbial redheaded stepchild, first of Philadelphia in the seventeenth and eighteenth centuries and since then, of New York City. Today, Jerseyans cling—when it suits us—to our own identity. There are Jersey radio stations, newspapers statewide proclaiming their Jersey roots and even some natives seeking in court to make the New York Giants football team the New Jersey Giants, a gambit that failed, though two Irish-Americans named Barry and McConnell from Byram Township almost won that fight.

Too often the perception of northern New Jersey as a distant borough of New York and south Jersey as an extended part of the "Philly Nation" is more reality than many natives care to admit, and this defensive posture of

the Garden State has been a fact since the 1600s, when New Jersey's European settlement began in earnest.

Part of the problem lies in definition. Who, really, is a New Jerseyan? Vast numbers live in the state but work in New York or Pennsylvania. Untold more work in New Jersey and commute home to Philadelphia, Brooklyn, Delaware or suburban Pennsylvania. A similar predicament has confounded early writers of Irish-American history. When Dermot Quinn published the first and much-needed *The Irish in New Jersey* in 2004, he spent the entire first chapter trying to decide who, indeed, was Irish. In the end, the only conclusion the Dublin-trained historian drew is the somewhat exasperating: "The Irish story is complex." New Jerseyans understand completely.

John T. Cunningham is rightfully admired as the premier historian in New Jersey history. Cunningham's first book *This Is New Jersey* was published in 1953 and has never gone out of print in over fifty years. Cunningham has published more than two dozen books on New Jersey topics and produced more than twenty documentary films on historical New Jersey, but he has not focused specifically on the Irish. The novelist/historian Thomas Fleming is living proof of the New Jersey cultural crossover. Born and raised in Jersey City, Fleming is currently a resident of Manhattan. Perhaps the most prolific and famous author in state history, Tom Fleming has written over forty novels and nonfiction books, many with New Jersey themes, including the recent *Mysteries of My Father: An Irish-American Memoir*. Despite the efforts of Cunningham and Fleming, it was not until 2004 that a comprehensive history of the Irish in New Jersey was undertaken, and then by the aforementioned Dermot Quinn.

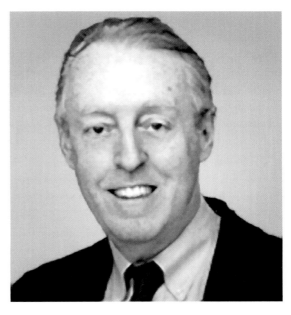

Tom Fleming, of Jersey City, is a Pulitzer Prize–winning author of over forty books, many with Irish themes. *Jersey City Public Library.*

Some chroniclers in the past have ignored or downplayed Irish importance in New Jersey for simple reasons of bigotry. Hard as it may be for modern-day Irish-Americans to fathom, the New Jersey legislature overthrew the Jersey City municipal elections in 1880 because several local Irish were elected to office. This fifteen years after the Civil War, not in a small village, but in the state's second-largest city.

Decades later, the lack of sentiment for the Irish was still evident in the Garden State. During World War II, many Irish-Americans trained in from Wilkes-Barre, Scranton and small towns in eastern Pennsylvania to work in munitions plants throughout the metropolitan area. On their return home for visits on weekends, they saw signs on more than one train station depot: "Irish Not Wanted or Welcomed," "Dirty Irish Not Needed" or worse. This story was still in the minds of seventy-five-year-old men in 2006 when I visited Scranton for a Saint Patrick's Day parade. Ironically, this occurred in, among other places, Hackettstown, a beautiful Warren County town founded by an Irishman from Tyrone.

Bigotry aside, much New Jersey Irish history has understandably been merged with that of New York or Pennsylvania. The legendary Irish Brigade, formed in New York during the early days of the Civil War, included the Eighty-eighth Regiment as one of its three original infantry units. Many of the Eighty-eighth were New Jersey men, especially from Jersey City. In fact, General Thomas Meagher, the most famous leader of the brigade, lived in Jersey City with his first wife, Elizabeth Townsend.

The same holds true in South Jersey. Pennsylvania had the 116th Infantry, and though not specifically an Irish unit (it carried no green flag), it was often almost one-third Irish, and its two top officers were Colonel Dennis Heenan and St. Clair Mulholland, a Lisburn man. Many of the 116th were from Camden, Trenton and South Jersey. Additionally, not every soldier signed up in his local area. The New York 48th, for example, was raised by two Irish ministers, and its regiment had dozens of Monmouth County Irish gossoons in the ranks.

The Irish in New Jersey have often thus taken a backseat to their big river cousins, and that holds true in education as well. The past two decades have seen an explosion of interest in Irish studies, both in undergraduate and graduate degrees, across the country. Fordham and New York University presently give such degrees, and Boston College and Notre Dame have the preeminent Irish studies programs in the United States, with Southern Illinois, tiny Marquette and even the University of Wisconsin not far behind.

Princeton, founded in part by Irish Presbyterians, provides for degree programs in Jewish, German and African American studies but has no Irish

studies programs. Princeton does possess possibly the finest collection of Irish poetry in the United States, a gift of alumnus Leonard Milberg. Begun in 2002, the collection holds more than two thousand first-edition premier works of Irish poetry and is growing rapidly. Rutgers, the state university, is without question the most diverse Jersey school when it comes to undergraduate degrees. It has programs in Jewish, Asian, Italian, Puerto Rican, Latin-American, Russian, Slavic and Spanish studies, but nothing close to Irish.

New Jersey's two largest Catholic schools, St. Peter's and Seton Hall, have not yet followed the lead of Fordham, Marquette and Catholic University. St. Peter's has little even in the way of course offerings, though it has served many of New Jersey's Irish sons and daughters, whose ancestry make up 40 percent of the state's population. St. Peter's and Seton Hall offer degrees in Asian, Latin-American and Africana studies, but like Princeton and R.U., no Irish. Seton Hall does house the MacManus Irish History and Literature Collection, with approximately three thousand titles, but it is not a prized compilation. Seamus MacManus, born in 1868, was an ardent Donegal nationalist who was a prodigious writer of Irish history. He married the famous feminist writer Ethna Carbery (Anna Johnston) in 1901, but she died the next year. In 1911, MacManus remarried at age forty-two, this time to a granddaughter of a former Venezuela president, Catalina Violante Paez.

In 1950, ten years before MacManus died from a fall from a window in a New York City nursing home in 1960 at age ninety-two, Seton Hall purchased part of his library from the widow of his brother, Meagher MacManus. Not one Irish university or Irish antiquarian book dealer bid within half of the Seton Hall offer. There has always been a strong suspicion that the purchase consisted of leftovers. Monsignor John McNulty, Seton Hall president at the time, was the buyer, in a deal consummated in the tearoom of the Gresham Hotel in Dublin. The collection was not unboxed or catalogued until well into the 1980s, lending suspicion to the rumors. It is, nonetheless, a nice collection, better to have than not, though Drew University in Madison, Rutgers and Princeton have the best Irish libraries in New Jersey.

Chronicling the history of the Irish in America began with the work of one man, Michael O'Brien. New Yorker O'Brien is a great American hero, though generally ignored and forgotten by historians. For sixty years, he researched Irish and Irish-American history in the original thirteen colonies. For twenty years, from 1912 to 1932, the Cork-born O'Brien was the historiographer of the American-Irish Historical Society in New York. He wrote and published more than 130 articles on Irish-American history while working full time for Western Union, as well as thirteen books on the Irish in America. O'Brien's

work, though lacking in academic style (he had no formal historical training), was clear, concise and, above all else, accurate. In 1932, the National University of Ireland conferred upon him an honorary doctorate of law.

O'Brien covered the United States from Maine to South Carolina, and among his works were the only researched articles he ever published on the Irish in New Jersey. These appeared in 1915, "Items Culled from the Records of the First Presbyterian Church in Morristown," and in 1928, "The Irish in the New Jersey Probate Records." O'Brien's range was prodigious, but despite sixty years of research, Mike O'Brien wrote only the two articles above about the Irish in New Jersey.

Since O'Brien relinquished his research efforts in 1930, little concerted efforts were undertaken on behalf of the Garden State Irish until 2004, with the exception of the mysterious W.H. Mahony (see "The Mysterious Mahony") when Dermot Quinn produced *The Irish in New Jersey*, which covered four centuries of activity within our borders. Quinn, a Seton Hall history professor, opened floodgates of interest, and though the book is heavily flavored toward Essex County and Seton Hall, it has without question sparked renewed interest in New Jersey history.

This work hopes to continue in a small way the pioneering work of Professors Quinn and Terry Golway of Kean University, as well as Michael O'Brien and Tom Fleming, with an arbitrary focus on common Irish and Irish-American citizens of our state, many of whom have left indelible marks on New Jersey history that should never be forgotten. There are hundreds of stories like the ones that follow, and the hope is to tell many more in the future. There can be little doubt that the further away we get from the lives and deaths of these *cos mhuintir*, the "plain people," the more important it is to remember them.

In a letter O'Brien sent to the New Jersey researcher W.H. Mahony in 1926, he remarked, "There are enough real Irish stories in American records to keep all researchers busy, even long after we have passed to the 'great beyond.'" May this work, in some small way, help prove O'Brien correct.

Tough Guys in a Tough America

"The Kid": William Gleason of Camden

Most professional baseball analysts and aficionados will be the first to admit that baseball is becoming a Latin-American game. More and more African Americans are turning to basketball and football, while white America is all over the map, plying their trade in every sport, thus thinning out their numbers accordingly, especially in the recently popular U.S. games, like lacrosse, soccer, golf and car racing. There are, to be sure, Irish-Americans still playing baseball (no Irish, however), but they are, while not rare, uncommon. In fact, a study of the 2008 spring training rosters for all thirty teams in the Major Leagues shows only twenty-eight unmistakable Irish surnames, or less than 2 percent, since spring training rosters are set at forty players per team. Twelve of the thirty major-league teams had no "sure fire" Irish surnames.

It was not always thus. In what some reviewers have called "the most important baseball book in the last twenty years," author Bill James states emphatically in *The Historical Baseball Abstract*, "The game was played by the Irish. Baseball in the 1890s was dominated by Irish players to such an extent that many people, in the same way that some people today believe that blacks are born athletes, thought that the Irish were born baseball players." O'Brien, Kelly, McGraw, Corcoran, Delehanty, Larkin, McCarthy, Duffy, Canavan and dozens of other "Paddy" names not only dominated the majority of rosters as Latin names do today, but they were also stars.

Ireland native Jack Doyle is one of only twenty major leaguers to have played one hundred games at four different positions and was baseball's first pinch hitter in 1892. There were thirty-nine players born in Ireland who had major-league careers. With the exception of Joe Cleary in 1945, every Irish-born player's career was between 1871 and 1918. Hundreds more were first- or second-generation Irish-Americans, many from New Jersey. More than one hundred Irish or Irish-American major-league players have either been born or died in the Garden State.

Among the first pros were brothers Hughie and Mike Campbell, natives of Ireland and residents of Newark. The brothers both debuted in 1873, Hughie as a pitcher and Mike as a first baseman. Pitcher John Harkins was from New Brunswick and pitched for five years before becoming a college coach at Yale, Lehigh and Princeton. While at Yale, he coached with Amos Alonzo Stagg, one of the most revered sports figures in United States history. Harkins, whose parents were both Irish born, is buried in his hometown at St. Peter's Cemetery.

Paterson resident Ed Nolan pitched for five teams in eight years before arm injuries ended his career with an earned run average (ERA) of 2.98. He is buried at Holy Sepulchre Cemetery in Totowa. Monmouth County had "Turkey Mike" Donlin, who in fifteen years had a lifetime batting average of .303. Donlin's post-baseball career was even better. He married the actress Mabel Hite and moved with her to Hollywood. Turkey Mike ended up an actor, appearing in forty-six movies in twenty-three years. He died of a heart attack at age fifty-five and was buried in the family plot in West Long Branch.

Larry Corcoran, though born in Brooklyn, was raised in East Orange and became a true superstar pitcher. Corcoran was a machine, winning 170 games in five seasons with Chicago of the National League from 1880 to 1884, including three no-hitters. Corcoran was also the first pitcher to arrange signs with his catcher, moving his tobacco chew from one side to the other to signal his pitches. The ambidextrous Corcoran was also the first professional player to pitch with both hands. After throwing out his arms, the heavy-drinking pitcher briefly turned to umpiring before dying of Bright's disease at the untimely age of thirty-two. Mourned by many at his early demise, Corcoran lies buried in his hometown of East Orange.

But the favorite baseball son of Irish New Jersey had to be William "Kid" Gleason. He was everything one would expect from an Irish kid from Camden. Feisty, spirited, a team guy, relentless, smart and, above all, loyal, he was a good-looking Don Zimmer with talent. William Gleason was born one year after the end of the Civil War on October 26, 1866. His father, also named

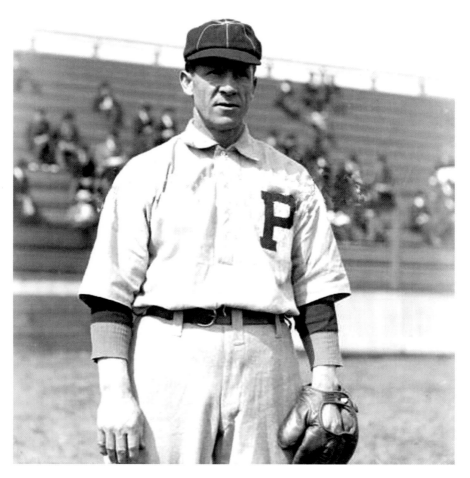

William "Kid" Gleason was a Philadelphia player prior to managing the Chicago White Sox. *Library of Congress.*

William, was born in Pennsylvania to Irish immigrants. His mom, Ellen, was the daughter of Irish emigrants in New Jersey. Most of the Gleasons settled in the Camden area during the war. William was the middle of five children, with both older and younger brothers and sisters. He was not called "Kid" until he started his baseball career.

During his teens, the Gleasons moved for a few years to the Pocono area of Pennsylvania, but William returned to Camden before he was twenty to play ball. Here he was called "Kid," not so much because of his five-foot-seven and 155-pound body, but due to his constant zest for the game. The

moniker stuck for the rest of his life. Gleason made the majors in 1888 as a pitcher and, in nine years on the mound, won 138 games, including 38 in 1890 with the Phillies. He had four twenty-win seasons. In 1895, he was switched to a position player, and as one of the highest-paid players in the game at $2,000 per year, he stayed a regular until 1906, when age and injuries slowed him down.

The Kid was considered one of the best infielders and teammates in the Major Leagues, and he retired with almost two thousand hits. He finally left as an active player after twenty-four years in 1912. Though he was called the Kid, there was no doubt he was tough. One day early in his St. Louis career, a stingy owner imposed a $100 fine and withheld it from his pay envelope. The Kid marched into his office and yelled, "Look here, you big, fat Dutch slob! If you don't open that safe and get me the $100 you fined me, I'm going to knock your block off!" Gleason left the room with the money.

Gleason was immediately signed as a coach following his retirement and eventually was promoted to manager of the most famous and infamous team in baseball history, the Chicago "Black" Sox of 1919. He did a masterful job of managing some of the most talented but difficult players into pennant winners, but when eight players decided to throw the series to gamblers, it almost killed the game. Though Gleason recognized it before anybody, his owner, Charles Comiskey, and baseball officials ignored him. When the gambling story finally broke and came to trial, Gleason was the first witness for the defense.

The Kid's reputation went unscathed—his was about the only one on any side of the scandal that did—but he never recovered physically or mentally. Though he stayed in the game for years, he felt, unnecessarily, that he could have done more, and he never got over the duplicity of his renegade players.

There were several key incidents in Gleason's off-the-field life. On April 26, 1900, the Kid and Irish teammates George Davis and Mike Grady were on their way to the Polo Grounds in New York for a game when they noticed a fire in a nearby apartment building. Davis climbed a ladder and rescued a woman, and then Gleason led another woman and a young child to safety down the burning fire escape. The fire left forty-five families homeless but alive, and all three players walked away and said nothing about their deed. It was typical of Gleason.

The second story did not have quite the same happy ending. In Cuba for the first time, on a baseball tour just months after the fire, a number of players convinced the Kid and Dodger outfielder Tom O'Brien that drinking an excessive amount of seawater, though it would make them sick, would

permanently cure seasickness. Both players fell for the ruse and became violently ill. Gleason recovered, but O'Brien suffered severe internal damage and died soon afterward from the prank.

Gleason returned to the Camden area after 1923 and eventually lived in Philadelphia with one of his stepdaughters, Mamie Robb. He died peacefully in his sleep on January 2, 1933, five years after his wife, at the age of sixty-seven. A crowd of ten thousand people showed up at his funeral, including a Camden woman who claimed to be his widow but hadn't seen him for thirty-seven years. Ms. Robb said Gleason had divorced the woman, Elizabeth Gleason, years before.

Upon his death, John McGraw said of Gleason, "He was, without doubt, the gamest and most spirited ball player I ever saw, and that doesn't except Ty Cobb. He could lick his weight in wildcats and would prove it at the drop of a hat."

THE "TOY BULLDOG": EDWARD PATRICK WALKER

You learn in life there are always ups and downs. We must have enough sense to enjoy our ups and enough heart to get through our downs.
—Mickey Walker

It is a good name, perhaps hinting of the law—Edward P. Walker, Esquire. Maybe even clerical, like "Father Ed" Walker. Was his mother, Elizabeth (Higgins) Walker, attempting to choose a patrician-sounding name with faint hopes for her boy's future? If she was, it did not work. Mike and Liz's boy was never an Edward, not even a Pat. He did, however, become the great Mickey Walker of New Jersey and later earned an even tougher moniker, the "Toy Bulldog," recognizable to the whole boxing world and beyond.

Mickey Walker was never shortchanged in the ring or out. Indeed, like his boxing career, he often took life on his own terms, beat it up and, in turn, was battered and bruised before finally losing the last fight and dying at age eighty in Freehold, New Jersey, in 1981. The Mickey Walker story is a roller coaster ride filled with every imaginable anti-Irish sentiment, from uneducated thug to drunken paddy to financial miscreant, all of which contained some grain of truth. But Mickey Walker will be remembered not just for his Hall of Fame boxing career but also as an accomplished painter, golfer, lover of life and

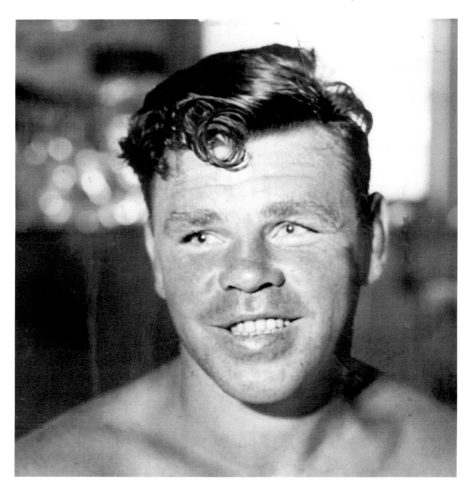

Mickey Walker, the "Toy Bulldog," was the pride of Elizabeth and one of the most feared boxers in America. *Elizabeth Public Library.*

arguably one of the most respected men in a man's world, the United States of 1920–50.

Walker was born on July 13, 1901, in Keighry Head, one of the several Irish neighborhoods in Elizabeth. His father, Michael Walker, was a first-generation Irish-American from Holyoke, Massachusetts. Mike turned down a pro boxing career in New England for one reason—he hated to fight. He left Massachusetts and came to Elizabeth in 1899 for a brief construction job before entering the priesthood. But soon after arrival, he was struck by the thunderbolt of love for a young girl, not the Roman collar.

Liz Higgins was herself first-generation Irish. Her parents, Pat and Mary, were both Irish emigrants who arrived in 1869, settled in Elizabeth and, by 1900, owned their own construction company, as well as a stable of horses. Today, the Kerry area of Elizabeth is as utterly different from 1900 as can be imagined driving on Route 1, with its go-go lounges and asphalt neighborhoods, with one exception—it was as tough then as it is now.

Edward Patrick was the first of three children Liz and Mike would have, followed by Marie, who drowned at seventeen, and Joe, who, like his brother, would lead a full life. From the get-go, Mickey was a handful. Even the nuns at Sacred Heart Grammar School, who had more patience—and bigger sticks—than the cops, could not control the oldest son of gentle Liz Higgins and priestly Mike Walker. It wasn't long before Mickey was putting up his hands professionally behind his father's back. His first fight, on February 19, 1919, earned the eighteen-year-old ten dollars in a four-round draw. In little more than a year, Mickey fought sixteen more times, all in Elizabeth and all wins. In 1920, his eighteenth fight, he was knocked out in the first round in Newark by Phil Delmontt.

The boxing audiences loved him. Walker fought one way—attack, attack and attack. He led with his head, and though his face took different shapes, he didn't care. Though often reckless, Mickey was never a palooka and learned from every opponent he faced. By the incredibly young age of twenty-one, he fought for the world's welterweight championship, and the five-foot-eight Irishman from Elizabeth beat the reigning champion, Jack Britton. He became a national star overnight in a sport whose popularity ranked right behind baseball.

In 1925, Mickey stepped up to the middleweight division, fought for the championship and lost. Before and after this fight, he continually defended his welterweight crown. In one of Walker's most legendary bouts, he fought as a middleweight against the future Hall of Famer Harry Greb, whom many experts say is the greatest middleweight of all time (Greb was the only man ever to beat heavyweight champ Gene Tunney). Mickey and Greb were two of a kind. They both loved a good time, strong drinks and beautiful women. Most importantly, they were both brutal fighters who took and gave no quarter. It was no surprise that more than sixty thousand fans showed up at the Polo Grounds in New York to watch these two go at each other.

Before it was all over and Greb won in fifteen rounds, both men had hit each other legally and illegally and had even knocked down the referee a few times. Greb broke his hand hitting Walker in the head, but Mickey never went down, and Greb didn't stop punching. It ranks as one of the greatest

fights of all time. Following the decision, both men met at a local tavern, had a few drinks together and then beat the hell out of each other on the street, with Mickey claiming that decision. The rivalry, unfortunately, never was allowed to blossom; Harry Greb died of a heart attack just months later at age thirty-two.

But the Toy Bulldog yearned for more, and on November 22, 1926, he captured the middleweight championship over world champ Tiger Flowers. In 1932, Walker even fought four fights as a heavyweight at the incredibly light 175 pounds. He won three of those fights against very legitimate contenders before getting knocked out by heavyweight champ Max Schmeling in seven rounds. Unfortunately, Mickey probably lost the Schmeling fight because he trained on a golf course with champagne. Walker carried the clubs, the caddy carried the bottles and, according to reporters, no one kept score, but on bad holes Mickey used up three bottles. In the next three years, Mickey went up and down from welterweight to heavyweight before he retired in 1935. The Toy Bulldog's overall record as a professional was ninety-three wins, fourteen losses, four draws, forty-six no decisions and one no contest in 163 bouts. His sixty knockouts rank with the best of all time.

In 1939, Mickey was partying when news of the start of the Second World War came over the radio. Then thirty-eight, Walker raised his beer and said, "Gentlemen, this is my last drink. I'll never take another as long as I live." He never did.

During his boxing career, two famous managers, Jack Bulger and Jack "Doc" Kearns, represented Mickey. The loyalty—and escapades—with both these men were played out across the country and became legendary. Walker became not only a better boxer with Kearns but also a Hollywood party boy and idol. Together they earned over $8 million in less than seven years and spent almost every dime. There was one legendary match in England where Mickey made $1 million in a London fight, then chartered two planes to Paris for his entourage and came back home two weeks later when the money ran out. During his boxing days, he hung around with Charlie Chaplin and Al Capone. He actually cocked a fist at Capone before a friend stepped in. "You saved his puss," the Bulldog grumbled. "I saved your life," replied his friend.

In 1955, Mickey Walker was inducted into the United States Boxing Hall of Fame along with six other fighters: Benny Leonard, Gene Tunney, Harry Greb, Joe Walcott, Abe Atell and Terry McGovern. The New Jersey Irishman received the most votes of that class, and in 1990, Mickey was one of the original members of the International Boxing Hall of Fame. The "Toy Bulldog" from New Jersey was indeed the real thing.

After leaving boxing at age thirty-four, he opened a very popular and successful restaurant in Manhattan near Madison Square Garden. It was successful for a while, but Walker never could handle money. He spent half a million dollars trying to learn polo and move up the society chain by moving to Rumson down on the Jersey Shore, but he failed both at polo and with society.

Mickey also wrote newspaper columns and became a professional artist, with successful shows in both European and American art galleries. He specialized in primitive art, and his paintings today are highly valued. But in these post-boxing years, Walker still was unable to control his finances, and when added to his six (maybe seven) marriages, he was basically broke during the last twenty years of his life.

The end, as with so many other meteors in life, was not so kind, but even with a bad finish, Mickey Walker was inspiring. In 1974, the police found Walker, appearing to be drunk. Though Mickey's fondness for booze was well known, he had not had a drop for some thirty-four years. The cops took him to a nearby hospital, as Mickey was not able to—or would not—identify himself. But sometimes fate goes as fate must. Mickey was suffering from Parkinson's disease, anemia and hardening of the arteries. Then Dr. Charley Gellman stepped into the picture.

Gellman was originally a young Jewish boxer from North Bergen, New Jersey, who found his way into medicine. He met Walker in a gym as a young man and never forgot the kindness with which the older champ had treated him. Now it was his turn. "He was a pitiful sight," said the doctor. "He was suffering so much it could have made you cry. We stabilized him physically, but not mentally. He was very senile and could not remember anything." At one point Gellman felt Walker was becoming lucid, but he was wrong. Mickey was talking about Harry Greb. "Yeah, great fighter, that Harry," said the Toy Bulldog. "Is he still fighting?" Greb, of course, had died in 1926, forty-eight years prior.

Many people heard the story of Mickey and Gellman. Most of Mickey's medical needs were taken care of by the state, and the rest came from the goodness of Charley Gellman, who even had Mickey transferred to a nursing home in Freehold, New Jersey. There, in an advanced state of Parkinson's, Mickey Walker fought for life just like he had as a kid in Keighry Head. Seven years later, Edward Patrick Walker, who lived life to the brim and whose smile was as great as his punch, died on April 28, 1981.

WARRIORS AGAINST ENGLAND

"MUTINY IN MORRISTOWN": THE PENNSYLVANIA LINE IN 1781

The largest concentrated Irish population in New Jersey prior to 1800 was so unhappy with living conditions in Morristown, Morris County, that they hurriedly left en masse and traveled south to Princeton, an early sign of white flight. This sudden exodus of more than fifteen hundred American soldiers of the famed Pennsylvania Line, with perhaps one thousand Irish or Irish-Americans leading the way, were so fed up with New Jersey that on New Year's Day 1781, they decided to simply walk home to Pennsylvania.

This was not, however, a sudden decision. The famed fighting force, so beloved by General George Washington, had spent the previous winter of 1779–80 encamped on the beautiful hills overlooking Morristown, an area now known as Jockey Hollow, off present-day Route 202. By Christmas 1779, these veterans had already fought for the United States for three long years. They were, almost without question, the largest and most famous colonial unit in the Revolution. Dr. David Ramsey has said, "They were inferior to none in discipline, courage, or attachment to the cause of independence." They served everywhere and surrendered nowhere and, for the most part, were "natives of Ireland."

Washington himself selected them to cover the retreat of the American army in August 1776, and all four of their commanding officers were Irish

born. One wag wrote, "Though officially called the Line of Pennsylvania, they could easily be called the Line of Ireland." Washington, their commander in chief, loved them. As spring approached in 1780, he signed the following proclamation in Morristown:

> *The General congratulates the Army on the very interesting proceedings of the Parliament in Ireland, and the inhabitants of that country, not only as they appear calculated to remove those heavy and tyrannical oppressions, but to restore to a brave and generous people their ancient rights and freedoms. The General thus directs that all fatigue and working parties cease for tomorrow, March 17, a day held in particular regard by the people of that nation.*

In addition, General Washington instructed Colonel Francis Johnston of the Pennsylvania Line to issue the following order:

> *The Commanding Officer desires that the celebration of the Day should not pass by without having a little rum issued to the troops, and has thought proper to direct the commissary to send for the hogshead which has been purchased already in the vicinity of the camp. While the troops are celebrating the bravery of St. Patrick in innocent mirth and posture, he hopes they will not forget their worthy friends in Ireland, who, with the greatest unanimity, have stepped forward in opposition to the tyrant Great Britain, and who like us, are determined to die or be free. The troops will conduct themselves with the greatest sobriety and order.*

It has been reported that the day "was ushered in with music and hoisting of colors exhibiting thirteen strips, the harp, and an inscription, 'The Independence of Ireland.'" These marvelous men, whom General "Light Horse Harry" Lee thought were such an extraordinary corps because they were largely Irish, got through this first winter in Morristown and participated in their fourth summer campaign, only to retire for a second Morristown winter in 1780–81.

But this time, Washington was not with them, and neither was the weather. Washington was in West Windsor, New York, and unhappy, but not as unhappy as the Pennsylvania Line, and soon Irish recklessness, impetuosity and ferocity would rule the day. The Christmas of 1780 would already have seen seven

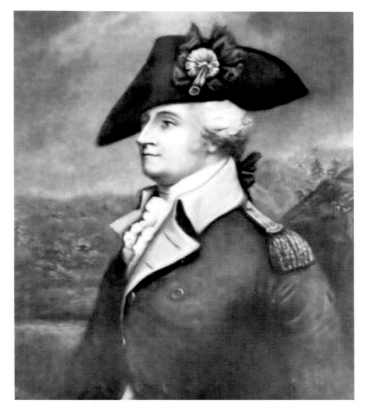

Descended from County Wicklow immigrants, General Anthony Wayne diffused the Pennsylvania Line mutiny with firm calmness and was loved by his men. *Library of Congress*.

blizzards in New Jersey, and the Arthur Kill between New Jersey and Staten Island, the East River in New York and the Long Island Sound would all freeze over in this coldest winter in more than a century. It was reported that a man could walk from Bayonne to Connecticut without getting his feet wet.

After three years of hard fighting, the Pennsylvania Line found itself without clothes, food or pay. Most had not received any pay for more than a year, and many were "close to naked and closer to famine." Some modern historians have said that the camp at Morristown was worse than Valley Forge. Despite the privations, this was not a rebellious group, and Irish-American general Anthony Wayne wrote:

> *Our soldiers are not devoid of reasoning faculties, nor are they callous to the first feelings of nature, but they have now served their country with fidelity for near five years, poorly clothed, barely fed, and worse paid.*

Now on the brink of starvation in this coldest of winters and almost naked, the Pennsylvania Line, whose enlistments were up on January 1, found another obstacle. Their $20 bounties received three years before had seen new recruits join their ranks with bounties now approaching or exceeding $500. Washington, well aware of this potential problem and of the dire straits in Morristown, argued their case with Congress and the state government of Pennsylvania. Both turned the great man down, and the situation in New Jersey turned ugly very quickly.

These veterans, predominately Irish, had had enough. They had enlisted for three years or the duration of the war, and many decided to reenlist and receive the new rich bounties. But the Pennsylvania Congress interpreted the phrase "for the duration" and refused to consider these as new enlistments. This was a dangerous game to play with starving, freezing men who had been unpaid for a year, and the politicians, as usual (then and now), were playing with the wrong crowd. So on that fateful January 1, 1781, New Jersey became the site of the largest mutiny in the history of the American Armed Forces, a mutiny both fomented and solved by Irishmen.

The British, of course, were not unaware of the dilemma. New Jersey, perhaps one-third Tory, had infiltrated the camp and had been passing out "free pardon" sheets. By 8:00 p.m., the Eleventh Regiment, mostly Irish, was unruly, and by 9:00 p.m., the entire camp was close to a mess; a mêlée soon broke out. In the initial craziness, two captains were shot and killed, and a lieutenant was wounded by what could only be described as a mob. Jockey Hollow was now wild, and though General Wayne, whose father was from County Wicklow, and the Irish-born Colonel Richard Butler of County Kilkenny pleaded with the men to return to their huts, they were unsuccessful. The men told Wayne that, in spite of the killings, they were not angry with officers, just with Congress. After a brief calm, the men—we can call them nothing but mutineers—went down the road south, while Wayne blocked the road to Elizabeth (and the British). Nobody at this point had a clue where this would lead. The leaders, many of which are anonymous, as most mutineers are, told General Wayne they were going to Trenton or Philadelphia and most definitely were not going to the British. Wayne didn't panic and simply responded, "OK, I'll follow you."

The Pennsylvania Line, now numbering about fifteen hundred of the original twenty-five hundred at the camp, marched in column and civilly—not a mob, but as regiments—and as they did so, Wayne asked each regiment to state its grievances. Two officers, Irish-born General James Potter and Colonel Francis Johnston of the Fifth Regiment, went to Philadelphia to tell Congress, and Wayne wrote to Washington.

Wayne had already anticipated the mood of the men and sent two officers, each Irish, to parlay with the line. Colonel Butler was the commandant of the Fourth Regiment, and his three Irish-born brothers were with him, as was Colonel Walter Stewart of the Eleventh Regiment, a Pennsylvanian born in Donegal. It has been estimated that 36 percent of the sergeants of the Pennsylvania Line were native Irishmen, and they formed 22 percent of the rank and file. In addition, at least another large amount was first-generation Irish.

The line followed what we know now as Route 202 to Bernardsville and was soon in Pluckimen, but when the men reached Bound Brook, they stopped and replenished their food with the one hundred cattle they had "borrowed." This was certainly not a minor issue, and the New Jersey militia was stationed between the line and the British, just in case. Joseph Reed, the Irish-American president of Pennsylvania, sent fellow Irishman

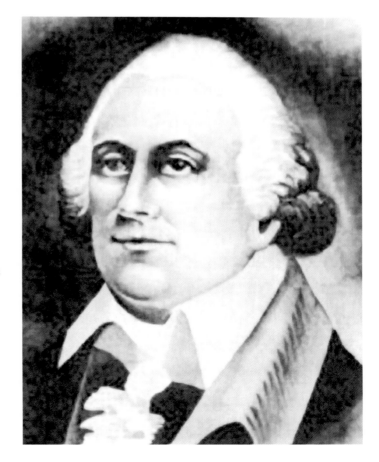

Colonel Stephen Moylan was born in Cork and immigrated to America in 1768, serving as a staff member to General Washington during the war. *Library of Congress.*

Colonel Tom Preston and three other officers from Pennsylvania to head them off from Philadelphia.

By January 4, the fifteen hundred mutineers were now in Princeton, and the mutineers' "committee of sergeants" met with Wayne, Stewart and Butler. Everyone agreed that another committee would go to Philadelphia and state their case, while the main body remained in Princeton. Washington never panicked, and his calm enabled a peaceful solution. He kept in constant touch and was very worried, but he told Wayne and the other Irishmen to handle it.

On Thursday, January 5, the Irish-born Colonel Stephen Moylan joined the three American officers. Washington had sent Moylan, and the mutineers—almost all the rank of sergeant and below—agreed to talk. Moylan, born in Cork and whose brother was a bishop of Cork, joined Wayne and the two Irish colonels, the Derry-born Charles Thomson and Francis Johnston. The British countered with another Irishman, Hugh Haggerty of Wantage, New Jersey, and a well-known Tory in an attempt to infiltrate the camp.

Friday January 5 saw no change. Joseph Reed got as far as Lawrenceville but felt unsafe near the unhappy soldiers and went back toward Trenton. After meetings all day, the entire unit of mutineers was granted "general amnesty," and while these negotiations were being held, Wayne, Butler, Stewart and Moylan were with the soldiers, who trusted them and appreciated their honesty and concern for their actions. Two men—John Mason and James Ogden, British agents—and a third, John Williams, were turned over to Wayne, who turned them over to Reed. Reed, in turn, gave them to his aides, Blair McClenahan and Alex Nesbitt, both Irish born, who had them hanged on the Pennsylvania side of the Delaware, taken there by the ferry master, Irishman Patrick Colvin.

A great majority of the mutineers showed their true American colors and reenlisted, being granted a few weeks' leave to be with their families. The heroes of the day in an incredibly tension-filled time were General George Washington, who did not panic and assigned seven valuable people, six of them Irish or Irish-American, to diffuse the largest mutiny in Unites States history. Count as Patriots, too, the unknown Irish sergeants, who were able to work with fifteen hundred of the most loyal yet angry men America has ever seen. Today, Morristown is home to some of the most popular Irish cafés, pubs and clubs in New Jersey. We've come a long way in two hundred years.

"The General Who Invaded Canada—Twice": John C. O'Neill

Throughout the bloody Civil War, agents for a secret Irish organization were allowed to openly recruit members in both the North and South for the purpose of raising a separate army. This military force, called the Fenian Brotherhood, would by war's end claim more than 200,000 members worldwide, the majority in the United States. Each member paid a dollar initiation fee and ten cents a week dues. The Fenian oath, like most oaths of secret organizations, oozed of man's kindness to his fellow brothers, but their goal had nothing to do with love:

> I, _____, solemnly pledge my sacred word of honor, as a truthful and honest man, that I will labor with my earnest zeal for the liberation of Ireland from the yoke of England, and for the establishment of a free and independent government on the Irish soil; that I will implicitly obey the commands of my superior officers in the Fenian Brotherhood, that I will faithfully discharge the duties of my membership as laid down in the constitution and by-laws thereof; that I will do my utmost to promote the feelings of love, harmony, and kindly forbearance among all Irishmen; and that I will foster, defend, and propagate the afore-said Fenian Brotherhood to the utmost of my power.

Despite modern thoughts that this must be far-fetched fiction, the Fenian Brotherhood (FB) was anything but a lightweight group, much less a joke. The FB was the only organization in American history to arm and drill publicly on American soil, and it opened an office in New York that had all the advantages of a foreign embassy and flew its own flag. The American wing, always impatient with the parent Irish wing, opted to fight sooner rather than later, choosing to attack Canada with an armed force of more than twenty-five thousand men, most of them trained veterans from the war.

Many current Americans, and most Irish, would be shocked to know that such a military force of Irish-Americans would invade Canada not once, but twice, and that the president of the United States would support them. Andrew Johnson had never forgiven Britain for its support of the Confederacy, including selling it warships, as well as harboring Confederate agents on

Canadian soil, and he met with Fenian Brotherhood leaders publicly and vowed to back them.

The brotherhood in the United States outgrew its parent control in Ireland, and thus two factions operated at the same time. The American wing decided to attack Canada on three fronts, forcing the British to defend its dominion and thus freeing up Ireland for an internal uprising. The Irish wing believed more time was needed and began its own timetable for disruption in Ireland.

In June 1866, Fenian fever gripped the nation, and rallies of thousands of public and private supporters were held in Newark and Jersey City. One fundraiser in New York City was attended by over 100,000 Irish eager for action, and soon armed men from all over the country were urged to head north. But poor leadership and logistics, a British spy and bad luck combined to disrupt the grand plan. In the end, the expected 20,000-plus men never arrived, and of those who did, only 600 actually crossed the St. Lawrence into Canada. On the political end, President Johnson abandoned his support once the operation initially failed, thus foiling any reinforcements for the 600.

But a hero would emerge from the failure. County Monaghan–born Colonel John O'Neill was the man who succeeded in crossing into Canada and won the one pitched battle now known as the Battle of Ridgeway. Following the battle, O'Neill and his mostly Tennessee force covered their retreat and surrender with bravery and dignity, and though initially arrested by the

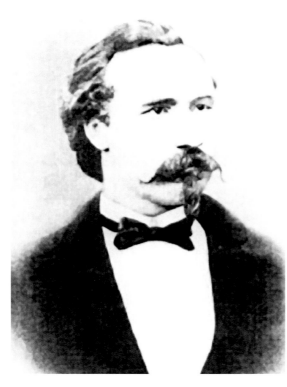

Born in County Monaghan, the Elizabeth-based Fenian Colonel John O'Neill became a national hero to Irish-Americans before dying at age forty-four in Nebraska. *Author collection.*

American navy, they were shockingly—at least to the British and anti-Irish United States press—all released and given free passes to return home by order of President Johnson.

Three facts emerged from the failed invasion: 1) though the Fenian movement was harmed and reduced, the Irish vote was still too important for any one of them to be jailed for invading another country; 2) Canada realized its vulnerability and strengthened its defenses; and 3) John O'Neill emerged as a mega national star. Within months, the colonel became a general of the Fenian Brotherhood and was elected president within a year. But the real story of the legendary General John O'Neill began and ended in New Jersey with a widowed mother searching for a better life.

At age eleven, O'Neill arrived in Elizabeth, New Jersey, to join his mother, Catherine O'Neill, and his older siblings, Mary and Bernard, at the height of the Irish famine. O'Neill never knew his father, who died of cholera just weeks before his birth. When Catherine joined her brother, John Macklin, in Elizabeth, she left baby John with his grandparents in Monaghan. By the time the future general joined the rest of the family eight years later in 1848, it was tough for him to catch up socially and psychologically. Mary and Bernard were adapting well to American life, and after school both worked in Uncle John Macklin's growing grocery store, one of the most successful ventures for the early Irish of Elizabeth.

Neither school at St. Mary's nor the grocery business fit the youngest O'Neill, and there are strong hints that he had problems with his brother Bernard and Uncle John Macklin. The stubborn, very handsome and bright O'Neill left school after just one year and the grocery business after three, working as a book salesman before opening his own Catholic bookstore in Richmond, Virginia. But the store failed, a foreshadowing of John's life in business. Following the failed venture, O'Neill would spend the next few years in the army fighting Mormons in Utah, until he deserted. He fell in love with an Australian orphan in San Francisco only to rejoin his unit (with no penalty) at the outbreak of the Civil War. A lifelong pattern of courage, quick temper and rash decision-making developed along the way.

But the war was perfect for men of O'Neill's abilities, and his leadership qualities were evident to all. His men adored him. In 1864, while recovering from exhaustion and a gunshot wound, he returned from the Tennessee battlefields to Elizabeth, where his Aussie fiancée, Mary Ann Crowe, was waiting for him at his mother's house on Price Street. They were married at St. Mary's, Elizabeth's first Catholic church, but old Irish feelings die hard, and John chose a Macklin cousin he had barely known to be his best man, not his only brother or uncle.

At the war's conclusion, O'Neill was a certified war hero and respected leader of the Nashville community, where he joined the Fenians. He led his men to Buffalo, and when the planned attack came undone, O'Neill was the senior officer and the only one ready to act. It was a serendipitous choice, but a great one, and O'Neill was soon a national Irish-American star. But his ego and rash decision-making hurt him, and his choice of the British spy Henri LeCaron to be his personal aide doomed him.

During the next two years, O'Neill lived large, some said too large, and his ego wouldn't let go of another invasion of Canada. There was less support from within the FB than there had been for the first attack, and LeCaron informed the Canadians of every move. This time, O'Neill was arrested in Vermont, tried for invading a foreign country and imprisoned for three months before being pardoned by the president, who still recognized O'Neill as a popular figure to a large segment of Irish America.

Removed from leadership, O'Neill licked his wounds in Elizabeth, where his family had settled during the attack in Vermont. General O'Neill couldn't sit still in New Jersey and eventually spent almost eight years roaming the country, convincing Irishmen to resettle in Nebraska. He tried to coerce the O'Neills and Macklins of Elizabeth, but Uncle John had the biggest grocery in town, and Bernard had a large family and business of his own. Both the O'Neills and Macklins were among the most respected and valued families in the city and would remain so for generations.

Catherine O'Neill's roving son, however, did convince several nephews to leave New Jersey and help him settle out West, which further exacerbated his relations with the family in Elizabeth. Though the colonization plan never quite succeeded on a grand scale, a few hundred Irish stuck it out, and O'Neill, Nebraska, was proudly named after its founder. Unfortunately, his incredible energy and pace of life took their toll on the man who loved being called "the General." John O'Neill, who left Ireland at age eleven; settled and married in Elizabeth; became a Civil War hero, an Irish patriot and an American celebrity; led invasions into Canada; and helped colonize Nebraska would sadly die of a stroke brought on by exhaustion and alcohol at age forty-four in Omaha in 1878.

The rebel of the New Jersey family lies buried in Omaha under a huge fifteen-foot monument, dedicated by Eamonn DeValera himself in 1919. On the East Coast, generations of other O'Neills remained in New Jersey, leading exemplary lives.

Both the rebels and the assimilators epitomize the distinct and disparate ways the Irish have adapted to American life.

"Fenians, Fenians, Everywhere": Four We Remember

While John O'Neill of Elizabeth was the George Patton of the Fenian Brotherhood, he was not the only New Jersey resident who joined the fight to free Ireland. Mike Gallagher, like O'Neill, came to New Jersey during the famine, settling in Jersey City. When the Civil War broke out, the twenty-nine-year-old Gallagher quickly enlisted in the Irish Brigade. The married father of two boys was mustered out after two years of vicious fighting, including the Battles of Antietam and Fredericksburg, but he had fallen in love with the army. After a brief spell at home with his wife, Mary Ann, and the boys, Gallagher reenlisted in the Second New Jersey Cavalry, only to be soon captured by the Confederates in Virginia.

Sent to the infamous Libby Prison in Richmond, Captain Gallagher, a native of County Westmeath, joined 108 other men in the most notorious escape of the war in February 1864. Fifty-nine soldiers succeeded, crawling through a fifty-five-foot tunnel, and soon Gallagher was back in Jersey City, where he joined the Fenian Brotherhood and saw his newly born third son for the first and last time. Recalled to the western theater, where he rejoined his fellow Jersey boys, Captain Michael Gallagher was shot through the heart and died instantly three days after Christmas 1864 in Corinth, Mississippi. He was buried in the field in what is now the Corinth National Cemetery, and his obituary in the *Irish-American* newspaper closed with the words: "Never did the grave close over a braver soldier, or one whose heart beat more warmly for Ireland."

Jersey City was also home to the only American soldier executed by the British government during the Fenian period. Michael O'Brien, the tall, gray-eyed native of Ballymacoda in the parish of Kilmacdonagh, Cork, joined the Fenians in Ireland. Immigrating to Jersey City in 1861, he joined the New Jersey Light Artillery in 1863 and was honorably discharged in June 1865. Immediately following the war, O'Brien returned to Ireland, working in Cork and running guns between Ireland and England for two years. O'Brien, who had become an American citizen, was eventually arrested in Manchester, England, for involvement with thirty other Irishmen in the successful jail breakout of fellow Fenians Tom Kelly and Tom Deasy in September 1867.

During the escape, however, British police sergeant Charles Brett was shot and killed, and O'Brien and four others were tried for murder. One man, Edward O'Meagher Condon, was freed after the intercession of the American

 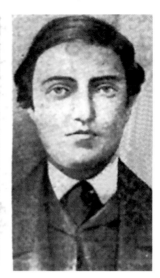

Mike O'Brien of Jersey City, far right, was the last American hanged by the British government. The American consulate refused to help. *Wild Geese Heritage Museum.*

government on the grounds that Condon was an American citizen. Mike O'Brien, for reasons still unexplained, was ignored by the American embassy, perhaps fearful of further upsetting British political sensibilities. William Allen, Michael Larkin and O'Brien were quickly found guilty and hanged three days later on November 23. O'Brien, a very strong man, supported Allen on the scaffold, while O'Brien and Larkin were forced into a most painful death when their necks did not break instantly and their legs had to be pulled to finish off the execution.

Irish nationalists the world over came to regard the three as the "Manchester Martyrs," and memorials were erected to them in both Manchester and Ireland, where they were counted as heroes. In his last letter to his brother, Michael wrote, "Let no man think a cause is lost because some suffer for it." In an ironic twist, Tom Kelly escaped to the United States and took up residence in Atlantic City, where he and his wife ran a hotel.

Fenians came in all shapes and sizes. Joseph Patrick O'Donnell, whose comfortable Irish family was never particularly passionate about Irish freedom, joined the FB in Dublin in 1863. A brilliant university student, J.P. graduated from Dublin University and entered Maynooth Seminary, his father's greatest wish. Almost immediately, O'Donnell was kicked out for refusing to take a pro–British government oath. Later, he would be jailed briefly both in Ireland and England for his nationalist tendencies. O'Donnell and his wife

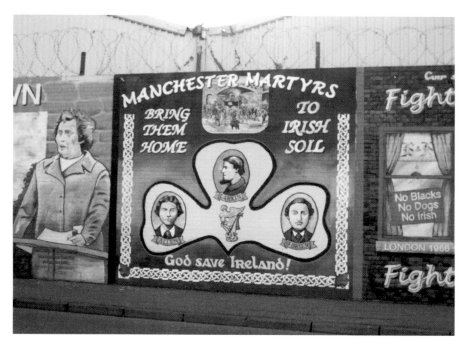

A testament to the Manchester Martyrs is still evident in nationalist Belfast 143 years after their execution. *Wikimedia Commons.*

immigrated to the United States, eventually taking up residence in the heavily Irish city of Paterson.

The small, thin, red-haired O'Donnell became, for more than twenty years, New Jersey's leading labor curmudgeon. He published and edited the influential labor newspaper the *Labor Standard* and fought crusades throughout the entire Garden State. J.P.'s lobbying efforts and fights for the workingman made him one of the most well-known citizens of the Garden State, and it was largely through his work that New Jersey became the first state to make Labor Day a holiday.

O'Donnell was not the only Fenian newsman. Jerome J. Collins was born in Dunmanway, County Cork, in 1841 and arrived in America right after the war in 1866, moving first to New York before settling in Newark. As a youth, Collins was trained as an engineer and, in New Jersey, was one of the pioneers reclaiming the marshlands we now know as the Meadowlands. He also worked as an engineer for Hudson City, later annexed to Jersey City and now known as the "Heights." After the Fenian military setback in 1866, Collins helped form a more secretive Irish freedom organization,

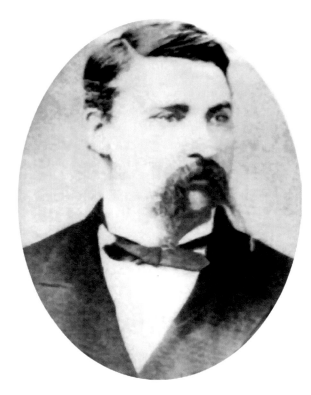

Left: The brilliant Cork-born Jerome J. Collins lived and worked in New Jersey, only to die in Siberia. *U.S. Naval Historical Center*.

Below: St. Mary's Cemetery, Curraghkippane, County Cork, the final resting place of Fenian Jerome J. Collins. *Amy Nossum Collection*.

Clan na Gael ("Family of the Irish"), a forerunner of the 1916 uprising. The tall and well-formed Collins was a brilliant man. He became a scientist who established the New York Weather Service and covered science and the weather for the *New York Herald*.

But like Michael O'Brien, Collins is remembered more for his death than his life. When his publisher, James Gordon Bennett, the man who sent Henry Stanley to Africa to search for Dr. Livingston, decided to sponsor an Arctic exploration, he asked Collins to go and report on the journey. Collins was thirty-eight, very fit and eager for the 1879 journey on the USS *Jeannette*. But he ran afoul of Captain George De Long, who despised the Irish, and Collins was very Irish.

The voyage was an abject failure, and the ship was surrounded by ice and held captive for almost two years. In June 1881, the ship sank, and the men were divided into two groups. One, led by an officer named Melville, reached a Siberian settlement and was rescued. The others, including Collins and Captain De Long, died of cold and exposure. In 1882, the navy ordered the *Jeannette's* dead to be returned, and Bennett got his headlines for weeks as the bodies were retrieved from Siberia and brought to New York. A monumental public memorial was held in New York, and then Collins's body was returned to St. Mary's Cemetery in Curraghkippane, Cork. This was forever after known as the "longest funeral in the world," his forty-year-old body having traveled fifteen thousand miles before it was lowered in the ground overlooking the beautiful River Lee.

"The Rifleman": Private Timothy Murphy

This country has been made by the Tim Murphys, by the men in the ranks...
Our histories should tell us more of the men in the ranks, for it was to them,
more than to the Generals, that we are indebted for our military victories.
—Franklin D. Roosevelt, 1929

One of the great enduring American legends is that of the frontier sharpshooter—from Dan Morgan of the Revolution to Daniel Boone, from Davy Crockett to the Mountain Men traders like Dan Fitzpatrick, straight through to Alvin York and Audie Murphy. The concept of the individualist backwoodsman with humble origins whose heroic deeds capture a nation has long been recognized as peculiarly American.

It will surprise many to know that one of America's most famous riflemen was born in New Jersey, of Irish parentage. Tim Murphy is not only an American legend but a son of New Jersey as well. But the idea of a New Jersey guy being a frontier sharpshooter was too much for many historians. Nine different writers, including the eminently qualified Francis W. Halsey and the equally solid Benson Lossing, have stated that Murphy was a Virginian. Jeptha Simms, historian of the Mohawk Valley, has written that Murphy was born in Pennsylvania. One other, Jay Gould, has said he was born in Ireland. They were all wrong.

Thomas Murphy arrived at the port of Philadelphia sometime between 1735 and 1750. One story has it that Murphy was from Carlow and ran away from home, eventually working his way to Philadelphia via Donegal. This oral history has Tom Murphy fighting in the French and Indian War for a Philadelphia-based unit and then moving, upon discharge, up the Delaware, settling on the Jersey side of the Delaware Water Gap in Sussex County with his wife, Ann (Lundy).

But there is no doubt of Timothy Murphy's birth in Sussex County in 1751. The closest church to the Water Gap was the Dutch Reform Church, ten miles upriver near what is now Port Jervis, New York, and here Murphy was baptized in 1755. Brothers David and John and two sisters named Mary were also baptized in the same New Jersey church. The first Mary obviously died as an infant, and the second one was named in her honor—a common practice of the times. Very little is known of any of the other children. Were the Murphys Roman Catholic? Family history and common sense say yes, but there was no Catholic priest or church this side of Philadelphia.

Tim and his two older brothers grew up on the Delaware, where they were well known to many of the local people. This area of New Jersey and across the river in Pennsylvania was a very dangerous place to live, with Indians a constant menace. There can be little doubt that Tim and his brothers acquired early survival skills in order to live. The entire Murphy family lived through burnings, raids and scalpings.

The hatred between settlers and Indians was mutual. When he was about ten, Murphy was apprenticed in the nearby Wyoming Valley of Pennsylvania. When Tim was sixteen, the Murphys moved farther west to Shamokin Flats, now Sunbury, in Northumberland County, Pennsylvania. There was a tiny Catholic settlement here, and Tim's older brother John settled here for good after the Revolution.

War arrived when Tim was twenty-four, and he and brother John enlisted in a company of Northumberland Riflemen in June 1775. They

served in the Siege of Boston, the Battle of Long Island and the retreat across New York into New Jersey. Additionally, Tim was part of every major battle fought in New Jersey. By 1777, Murphy was so proficient that he was picked to be part of a five-hundred-man select rifle unit headed by Dan Morgan of Virginia. They were sent to upstate New York and found themselves in the fight for Saratoga. At the request of General Benedict Arnold—then still a champion Patriot—Morgan sent the best of the best to take out British general Simon Fraser. Murphy climbed a tree and, with two shots, killed Fraser and his replacement, Sir Francis Clarke, at a range of over two hundred yards. All historical records show that this turned the tide of battle, and the Americans had their biggest and most important victory in the war.

Following Saratoga, Tim Murphy and the rest of Morgan's elite unit, which Washington called "Morgan's Partisan Corps" and everybody else called the "Shirt Men," joined the rest of Washington's army at Valley Forge. The following spring, though he was not part of the Battle at Monmouth, Murphy was in New Jersey pursuing the British as they retreated across New Jersey and into New York. The remainder of 1778 saw Tim and Morgan's sharpshooters back in the Mohawk Valley, fighting Indians and Brits. After four straight years on active duty, the stout and "well-made" Murphy returned with his family to the Schoharie Valley, near Oneonta, New York, where he joined the local militia. In the spring of 1780, Tim and a friend were captured by Indians and taken to Oquago. During the night, Murphy freed himself and his friend Alexander Harper, and they killed ten of the eleven Indians, leaving one alive to tell the story of the great white soldiers.

Murphy's greatest feat may have been the defense of the Middle Fort in the Schoharie area. When besieged by fifteen hundred Tories, soldiers and Indians, Murphy physically refused to allow his commander, a Major Woolsey, to surrender his force of two hundred militia. The militia sided with Murphy, and after a long siege, the British force returned to Canada. Not content with having averted a possible massacre and humiliating surrender, Murphy and his tiny force of riflemen harassed Johnson and his Tories and Indians all the way back to Canada. The fort that Murphy made famous was renamed Fort Defiance in his honor.

Still not content, this courageous man reenlisted and served under Irish-American General "Mad Anthony" Wayne throughout 1781, mostly in Virginia. Murphy was present at Yorktown when the British surrendered. Despite being well liked and incredibly courageous, Tim never rose above the rank of private, though he fought in the service for eight and a half years. He

was said to enjoy being what he was—an Indian fighter who fought for the liberty of his country.

Murphy was married twice and had a total of nine sons and four daughters. His progeny are many and are scattered throughout the East. Murphy, who never learned how to read or write, died at age sixty-seven in 1818. Until the very end, Tim Murphy never relinquished his hatred of Tories. Despite his lack of formal education, he was a leader of his community, active in local politics and owned much land throughout the Oneonta area, which was his final home. But make no mistake. Tim Murphy was an adopted, not native, son of New York.

THREE ORIGINALS

"THE MAN WHO INVENTED McGARR":
MARK McGARRITY

New Jersey has long been a haven for writers, many of them Irish. For centuries, the magical lights and bohemian lure have drawn genius from our towns and cities across the Hudson and beyond. Eugene O'Neill lived for a while in the tiny hamlet of Rocky Hill in Mercer County near the slow-moving D&R Canal, but the dark Irish-American wrote most of his powerful depressions elsewhere. F. Scott Fitzgerald was a Princeton University man but didn't stay in New Jersey for long, and he was one of the few Irish-Americans who wished he wasn't. Frank McCourt came close, but no cigar. McCourt, a New York City schoolteacher, wrote *Angela's Ashes* in New York and Milford, Pennsylvania, just over the Delaware on Route 206. Frank traveled back and forth through the Garden State, perhaps thinking of Limerick, family, heartbreak and humor, but even the most ardent Jersey guy can't stake a claim to *Ashes*.

New Jersey, however, does not lack for Irish favorite sons—or daughters. Tom Fleming is homegrown, born and raised in Jersey City. Fleming is a nationally recognized writer of historical fiction and history, specializing in New Jersey and the Revolutionary and Civil Wars. Fleming has published more than forty books since 1960, including many with an Irish theme. Every New Jersey native with Irish blood in particular should read *Memories of My Father*, the story of three generations of an Irish emigrant family from Jersey

New Jersey newspaperman McGarrity created the McGarr Irish mystery novels, publishing seventeen in a series before dying unexpectedly in 2002. *Jerry Bauer Collection.*

City—Fleming's own—and it is a story that encompasses Irish America, World War I, fathers and sons and life under Frank Hague in Jersey City.

Mary Higgins Clark qualifies as perhaps the favorite Irish daughter of New Jersey letters in this century. Born in New York City in 1929, Higgins began writing as early as age seven, but only after her first husband, Warren Clark, died in 1964 did she find herself writing full time. Since then, Mary, who has lived in Bergen County for decades, has written more than two dozen books and has been dubbed the "Queen of Suspense" by more than one loyal fan. Many of her fictional settings are in New Jersey.

Terry Golway, for a number of years the curator of the John T. Kean Center for American History at Kean University in Union, has been a prolific writer of many Irish and Irish-American histories, including *For the Cause of Liberty: A Thousand Years of Ireland's Heroes* and *Irish Rebel: John Devoy and America's Fight for Ireland's Freedom*. Most recently he has collaborated with Tom Fleming on *The Irish-American Chronicle*, a wonderful addition to any Irish-American library.

Paul Muldoon may be Jersey's—and the world's—most talented poet writing today. Born in Portadown, County Armagh, in 1951, Muldoon was the son of a schoolteacher mother (Brigid Regan) and a father who cultivated mushrooms. He started writing as a child in Irish but switched to English when he went to Queen's University in Belfast, where Seamus Heaney became an early mentor. Muldoon has been a resident of the Princeton area since 1986, and the *New York Times* has called the Princeton University professor "one of the two or three most current accomplished poets in the English

County Armagh–born Muldoon has worked at Princeton University for over a decade, winning a Pulitzer Prize for poetry in 2003. *The* Guardian.

language." Muldoon won the Pulitzer Prize for poetry in 2003 for his work, *Moy, Sand and Gravel*. "The Loaf," a poem from that work, deals with a working man who, in renovating a house on the old Delaware and Raritan Canal, accidentally finds a tiny hole in the wall, with horsehair in the plaster, which evokes to the poet the unknown Irish, building, living near and dying in the canal. A line from that poem, "Spots of green grass, where thousands of Irish have lain," epitomizes the theme of this work.

Mark McGarrity never won the Pulitzer, and he never will; he died in July 2002 from an accidental fall outside his Morristown home at age fifty-eight. In truth, McGarrity, unlike both Fleming and Clark, was never able to make a living full time as a fiction writer. An avid outdoorsman, Mark wrote as a feature writer and nature columnist for the *Newark Star Ledger*, New Jersey's largest and best newspaper, until he died. McGarrity wrote several articles a week on everything from the environment to odd stories and people he found in New Jersey—and there was no shortage of either. At one of the best newspapers in the Northeast, Mark McGarrity was superior. But it was as a writer of Irish fiction, and the invention of chief inspector of the Irish Murder Squad Peter McGarr that made Mark McGarrity an exceptional New Jersey Irish legend.

This gentle, unassuming, slender native of Holyoke, Massachusetts, was so shy about his ability that he wrote under a pseudonym, Bartholomew Gill. In 1991, when he came in second to the great American writer James Lee Burke for an Edgar Award, McGarrity told his agent, "I was proud to lose to that guy."

In my brief acquaintance with McGarrity, I always assumed everyone at the *Star Ledger* knew of his Irish fiction. After all, he had written more than twenty books, including seventeen in the Peter McGarr series. To mystery fans and many Irish fiction readers, Mark McGarrity was a famous author. During the late winter of 2002, just a few months before Mark died, a *Star Ledger* sports columnist, Steve Politi, visited me at home and commented on my collection of Irish books. I mentioned I had all the first editions of his co-worker Mark McGarrity.

Politi was at first stunned, and then disbelieving, that this man worked literally five feet away from his desk. He had to be shown several of the books and the dust jackets with Mark's photo in the back. Still not sure, I gave him a new release and asked him to have it signed for me. A week later, it was returned with a kind note from McGarrity saying I had blown his cover at the *Star Ledger*. Politi later told me that McGarrity was gracious when his books were mentioned, but the "outing" engendered much merriment in the newsroom. For some months I felt guilty, and the guilt increased when Mark died in the summer.

All writers have a story of their own, and McGarrity was no different. After growing up in Holyoke, he went to Brown University, majoring in English. He soon found himself in Dublin, where he gained a master's at Trinity College, writing his thesis on Samuel Beckett. Like so many 1960s baby boomers, he found travel much more interesting than returning home to work. After Dublin, McGarrity landed in Siena, Italy, and soon ran out of things to read in English. As he later admitted, "I just thought I'd do the next best thing and began to write a novel." By 1977, at age twenty-three, Mark had created a detective book, *McGarr and the Politician's Wife*, and over the next twenty-five years he produced mysteries whose developments paralleled that of his ancestral homeland. McGarrity struck gold with his lead character.

McGarr's Murder Squad was a composite team of almost each segment of Irish society, but it was the chief inspector who held each book together. Once a heavy drinker and smoker who tracked thugs to their hideouts down backcountry boreens, McGarr became a nonsmoking teetotaler, and his criminals moved into overpriced city-center flats in Dublin. McGarrity sensed at times that his work would be difficult to gain a vast audience. American

audiences, unless they had a fine sense of Irish culture, would be hard-pressed to appreciate his authenticity, for his was not plastic paddy writing. Irish audiences, on the other hand, had some difficulty finding his work in Ireland, for reasons still hard to understand.

Over the years, McGarr was pitted against criminals from all levels of Irish society—organized crime, the IRA and even the Irish Opus Dei. Sometimes most revealing were the internal politics of the Dublin police and the different personalities of each member of McGarr's squad, which grew with him over the last quarter of the twentieth century. The most popular of the McGarr books were those where McGarrity's literary background came to the forefront, in particular *The Death of an Ardent Bibliophile* and *The Death of a Joyce Scholar*, the latter of which was nominated for an Edgar Award as the best mystery book of the year in 1989. The *New York Times*, in reviewing one of McGarrity's last books, *The Death of an Irish Lover*, said, "The contradictions Gill manages to unearth in one small, placid patch of Irish ground are simply astonishing."

The name Bartholomew Gill was taken from one of McGarrity's grandfathers, who for years would spin stories and yarns of Ireland with the young boy. Like McGarr, McGarrity had a wife and daughter. In the McGarr series, the detective's County Kildare, well-bred, Anglo-Irish wife, after years as McGarr's semi-partner, dies at the hand of criminals while helping McGarr solve a case. In real life, McGarrity, at almost the same time, was divorced from his wife of thirty-three years, the former Margaret Dull. In both his fiction and real life, McGarr and McGarrity each had one child, a daughter named Madeline, always known as Maddie. After years living in Cranberry Lake, Andover Township, Mark McGarrity moved following his divorce to Morristown. He also had a residence in Dublin and said many times that keeping the McGarr series active enabled him to visit Ireland on a regular basis.

In the last decade, the Irish genre of detective fiction has exploded with wonderful characters and superb writing from the likes of Declan Hughes, Alex Barclay and Brian McGilloway, just to name a few. Mark McGarrity, an Irish-American from Jersey, would in his own shy way have loved to be included with such company, but that didn't happen.

McGarrity, who was in excellent physical shape, returned to his second-floor apartment after dinner in Morristown on the night of July 5, 2002, and, having misplaced his keys, tried to reach over a railing to gain entrance through a window. The twenty-foot fall killed him instantly, and his landlord's daughter found him shortly after midnight. New Jersey lost a kind soul in Mark, and Irish detective fans lost a great character in McGarr.

"THE MYSTERIOUS MAHONY": WILLIAM HUGH OF NEWARK

In 1926, the American-Irish Historical Society published its annual journal, with its usual two dozen or so works of pertinent research of the Irish in America. Included in this 431-page volume was one article titled "The Melting Pot: Irish Footsteps in New Jersey," by a seventy-two-year-old retired businessman, William Hugh Mahony. It was the third of eventually nine articles Mahony would have published on the subject, but Mahony's own Irish footprints have dissolved with the tides of time.

Though Irish research has generally been thin in the Garden State until 1990, Mahony is the exception. Notwithstanding the two articles by the brilliant Michael O'Brien, there exists not a single historian, trained or untrained, who produced more than a singular piece or two on the Irish in New Jersey until the twenty-first century, except William Hugh Mahony, the Irish researcher who lived in the shadows and whose own life has been thrown out of memory.

William Mahony, the septuagenarian amateur Irish researcher, lived and died in obscurity. His Connecticut grave was only uncovered with a shovel in 2009. *Author collection.*

When the first and only book on this topic was published in 2004, author Dermot Quinn referred to "a certain William Mahony" in somewhat dismissive terms, no doubt because biographical information on the man was nonexistent. Yet anyone searching bibliographies on the Irish in New Jersey will find Mahony's work cited consistently. Who, indeed, was this unheralded man who preserved so much of our state's heritage but whose own life has been invisible?

Mahony, it turns out, was born in County Cork on July 7, 1853, before immigrating to Connecticut at age eight in 1861. His early upbringing is unknown, but by 1890 William was an American citizen and successful businessman. He remained a bachelor until age thirty-seven, when he married the much younger Josephine Mulcahy of New Haven, Connecticut. Josephine was the daughter of Irish immigrants Bridget (Gaffney) and Mike Mulcahy, and though married for thirty-eight years, she and W.H. would have no children.

By 1900, the Mahonys were living on the West Side of Manhattan and operating a very successful dry goods business. Mahony was already a lifetime member of the prestigious American-Irish Historical Society (AIHS). Records show no other Mahonys in his life—no siblings, parents or others in over sixty years—but Josephine's family was another issue. William spent decades living, working with and supporting generations of Mulcahys.

By 1913, at age sixty, Mahony wrote a letter to Michael O'Brien, the preeminent Irish historian of his time in America. Mahony, from his new home in Newark, introduced himself, explained his lifelong love and commitment to Irish history and suggested several items that might be researched by the AIHS.

Mahony continued his formal and written relationship with O'Brien, but three years would pass before Mahony, at sixty-three, submitted a "humble effort to make popular and better known the Irish chapter in American history." It was not selected for print. But the dry goods retiree never gave up, and there is no doubt he hungered to be one of Michael O'Brien's protégés. In 1922, at age sixty-eight, Mahony's first article, "American-Irish Prominent in New Jersey State and Local Government," was published by the AIHS, then the nation's premier voice of Irish-American history.

In the course of the next eight years, the AIHS would print eight more pieces of research by Mahony. The first was followed by "The Irish Element in Newark," much of which was taken from an 1878 history of Newark by Joseph Atkinson, and then "The Melting Pot: Irish Footsteps in New Jersey in 1926."

The year 1927 was prodigious when Mahony had three articles published—a short piece on General Phil Kearny and "Some 17th Century

Irish Colonists in New Jersey," along with "Irish Footsteps in the Sands." "The Irish in Princeton" followed the next year. Much of Mahony's work came from research in the New Jersey Archives, a technique he learned from his mentor, Mike O'Brien. Mahony's ninth and last article, "Irish Settlers in Union County," appeared in 1930, but that publication followed the death of his beloved Josephine at their home on Broad Street in Newark, where they had lived for more than twenty years.

Josephine's death marked the end of Mahony in New Jersey and as a writer. Now seventy-seven, he moved in with a friend from the AIHS in Flushing, where he remained until 1938, unable or not wishing to work anymore. Mahony traveled back to New Jersey when he was eighty-five and stayed with a Mulcahy niece, Mrs. George McCartin, for a month in beautiful Avon. As the summer approached its end at the Jersey Shore, William Hugh Mahony, a Garden State pioneer, died peacefully in his sleep on Labor Day. He rests with the Mulcahy family, in a small plot next to Josephine, at St. Lawrence Cemetery in West Haven, Connecticut.

Though it is true that this valuable researcher was untrained, his value as a contributor to the history of his adopted state cannot be minimized. Mahony would be thrilled to know that in 1999, when Notre Dame University published the acclaimed *Encyclopedia of the Irish in America*, six Mahony articles would help develop the section on New Jersey. William Hugh Mahony is proof that an ordinary man, untrained and advanced in years, can produce extraordinary work.

"Simply the Best": James Barton

James Barton was a comic, a dancer, a storyteller, a singer, a dramatic actor and a radio and television star—and no one in America was as multitalented in those fields. The man whom "Bojangles" Robinson credited for his dancing style; the man who starred in Eugene O'Neill's *The Iceman Cometh*; and the man who ended his professional career acting in *The Misfits* with Marilyn Monroe was a New Jersey guy.

One critic, Alexander Wolcott, said Irish-American Jim Barton was "in the great company of Nijinsky and Charlie Chaplin." Another said James "was perhaps the most singularly talented of all headliners—sang as sensationally as Jolson, danced like Bill 'Bojangles' Robinson, and was a great stand-up

James Barton, age fifty, in the 1941 movie *Shepherd of the Hills*, with John Wayne and Ward Bond. *Author collection.*

comedian." Dance historian Marshal Stearns wrote, "In his day Barton was preferred by critics to Jolson, Cantor, Bojangles, Astaire, and Bolger." James Barton was an original who, aided by an Irish background of jigs and reels, absorbed the rhythms and movements of black dancers early in his career and ultimately added his own earthy, uninhibited genius.

James Edward Barton was born on November 1, 1890, in Gloucester City, New Jersey. His parents were James Charles Barton, a first-generation Irish-

American, and Clara Anderson, a vaudeville performer. "My Uncle John taught me my first step when I was two years old," Barton said. "I was part of the family act when I was four."

When not performing, the Bartons called Camden home, and that is where James lived until ending his formal education after the sixth grade. Jim, one of eight children, was carried on stage when he was two years old, and until he died sixty-nine years later, he never left. At no time did he regret it or ever feel like he was pushed by his parents. At four, he was playing Topsy in a tour of *Uncle Tom's Cabin* and was billed as "the boy comedian." He toured with his parents from 1897 until 1903, when he stopped going to school full time.

Jim Barton loved show business. "No kid had a better time. I can't remember how old I was when they began teaching me funny skits, dance steps, bits of songs. I was nuts about it," he said later. Barton went solo at age fifteen in 1905, chiefly in vaudeville, especially in the South and Midwest. In 1912, at twenty-two, he married fellow performer Ottilie Kleinert, but the marriage didn't last long.

Barton was not an early hit in the big cities—he honed his trade for years first. At age twenty-nine in 1919, he had a fill-in role during an actors' strike, and his performance stopped the show. Within months, Jim Barton was called "the man with the dancing feet," and he had another act as a drunken comic that was so realistic, people questioned his own sobriety. He kept this act for the rest of his career. With a solid reputation in New York, Barton played Broadway until 1927 and was always in demand.

In 1929, Jim toured nationwide, but in Baltimore he sustained injuries in a hotel fire that left his face scarred and his nose disfigured. Makeup fixed most of the problem, but it caused issues with his marriage, and after divorcing Tillie, Jim Barton married again, this time to Kathryn Penman, who had been a Ziegfeld girl.

In 1934, vaudeville was about done, so Jim went back to Broadway, this time in dramatic roles. He played the degenerate cracker Jeeter Lester in *Tobacco Road* 1,899 times in five years. James Barton was, in addition to singing, dancing and vaudeville performing, now considered a very talented and successful stage actor. Barton's success in *Tobacco Road* led to numerous stage, film and television roles for the rest of his life, although, with two or three notable exceptions, he was usually cast in supporting roles of the boozy, crusty, cantankerous sort.

Jim Barton's most distinguished achievement on stage came in 1946, when he starred as Hickey in the original production of Eugene O'Neill's *The Iceman Cometh*. Brooks Atkinson of the *New York Times* called his

characterization of the peace-peddling salesman "superb—common, unctuous, cheerful, and fanatical."

In 1951, Barton returned one last time to the musical stage in a starring role that gave scope not only to his singing, dancing and acting talents, but also to his legendary drunk routine: Ben Rumson, the variously hard-bitten and besotted prospector in Lerner and Lowe's *Paint Your Wagon*. Richard Gehman of Theatre Arts called Barton's performance "a magnificent personal triumph," and Atkinson extolled him in terms that reflected his longevity as a performer:

> *He gives one of those humorous, relaxed, lovable, and masterful performances that are peculiar to actors with a long and varied experience. Without strutting or hamming, he owns the stage. There is grandeur about the size of his acting despite the homeliness of the material.*

Jim Barton was also very active in television from the mid-1950s until his death. He appeared in several drama presentations, including the *Kaiser Aluminum Hour* and the *Kraft Television Theatre*. He also acted in *Playhouse 90* and appeared in such series as the *Naked City*, *Adventures in Paradise* and *New York Confidential*.

Barton was an outstanding amateur baseball player and played minor-league ball whenever his schedule would allow. He had no children in his two marriages but enjoyed true friendship and respect among professional performers all over the United States. Jim's last stint on Broadway was in the title role of the unsuccessful *The Sin of Pat Muldoon*, and his last film appearance, the year before his death, was in *The Misfits*, with a screenplay by Arthur Miller. In 1962, Barton died of a heart attack in Mineola, New York, at age seventy-one after an active career in show business that spanned sixty-six years and every venue and media, from vaudeville and legitimate stage to film and television. The recently created New Jersey Hall of Fame surely must include this native son, its most unique entertainer, bar none.

CLERICS OF ALL KINDS

"THE FIRST PRESBYTERIANS": JAMES CALDWELL AND NICHOLAS MURRAY

They could not have been more unlike. One was born in Virginia, son of a Presbyterian from Antrim who followed Cromwell to Drogheda. The other was a County Meath–born son of a Catholic farmer destined for the priesthood. One, an eighteenth-century early graduate of Princeton who studied under three of the most famous men of his time; the other, a nineteenth-century self-made man who ran away from home. The first was murdered by a rifle shot during the Revolution; the other died peacefully in bed almost a century later. One won people over with warm words, while the other beat them over the head, using words like a cudgel. But James Caldwell and Nicholas Murray will be forever inextricably linked in New Jersey Irish history, and they did have two things in common. They both fought their enemies with great passion, and they both served as pastors of the same church, First Presbyterian in Elizabeth.

James Caldwell was the first to arrive in New Jersey. He was born in Charlotte County, Virginia, in April 1734, the youngest of seven children. His father, John Caldwell, was born and raised in Antrim. James's mother was the former Margaret Philips, from County Derry. Together, John and Margaret raised a family of six boys and one daughter, Margaret. All were born in Ireland except baby James. The Caldwells landed first in Newcastle, Delaware,

before settling in the "Irish Tract" of Virginia after a stop in Lancaster County, Pennsylvania. This route—Delaware to Philadelphia to Lancaster and then south to Virginia (and, later, south to North Carolina)—was infamous as an Irish emigrant route for half a century. Here relatives joined them, all Irish, and the area became known as the Caldwell Settlement.

The Caldwells, as expected, considered themselves Irish, not Scotch-Irish or English. The term "Scotch-Irish" had not yet been invented by American revisionists. (For the record, they also did not consider themselves French, though some ancestors were French and fled as Huguenots after the Edict of Nantes; nor did they think they were Celts descended from Vercingetorix, though they may have been.) They were, to their neighbors, friends, enemies and the law, Irish. These Irish Caldwells spread, as did thousands of Virginian and Pennsylvania Irish, throughout the country, but James came to and married, lived and died in New Jersey.

Alone in his family, James was sent to Princeton, where he graduated in 1759, at age twenty-four. The three Princeton presidents when Caldwell was an undergraduate were Aaron Burr (the famous Burr, not the infamous son), Jonathan Edwards and Samuel Davies, three of the most learned and eloquent men in early colonial history. Caldwell, like many young sons of Irish families, embarked on the ministry immediately following graduation. He was ordained and then installed as pastor of the First Presbyterian Church in Elizabethtown in 1761. Two years later, he married a local woman from an esteemed family, Hannah Ogden. They would have nine children and would see none of them to adulthood, as both wife and husband would be murdered by 1783 during the war.

Not only was Caldwell an ardent Patriot in the conflict that marked the final twenty years of his life, but his in-laws, the Ogdens, were also vociferous rebels, as were noteworthy parishioners like Elias Boudinot, Abraham Clark, Francis Barber (another Irishman who did not survive the war) and William Livingston. One could—and they did—hold many meetings in the church. But New Jersey was at least 25 percent Loyalist, and not every First Presbyterian member was a Caldwell fan.

Known throughout the East as the "Soldier Parson," Caldwell was tireless both as a rebel and as a chaplain. He was loved by his men and hated by the Loyalists. In 1779, his house was burned down, and less than a year later his church was burned as well. Loyalists claimed responsibility for both, and the church burning was led by three Hetfield brothers, one of the oldest families in Elizabethtown history and parishioners and prewar friends of James Caldwell. Caldwell was known, just prior to preaching his

sermons, to take out two pistols and place them on his lectern. But things would get worse.

In June 1780, Caldwell retreated with Washington and Lafayette to Springfield Heights, right near the Hobart Gap exit on Route 24 (near the Short Hills Mall), when the British made a surprise attack—with Loyalist help—on Elizabeth and pushed through to what is now Union, committing many atrocities along the way. As they watched in safety from the Heights, Caldwell remarked to Washington and Lafayette that he was glad he had moved Hannah and the children to safety outside of Elizabethtown in Connecticut Farms (Union). He would not find out until the next morning that Hannah was killed while holding their baby daughter. Two bullets passed through her, and she died immediately. Lafayette, forty-four years later, in 1824, revisited the same spot and recalled the murder with clarity.

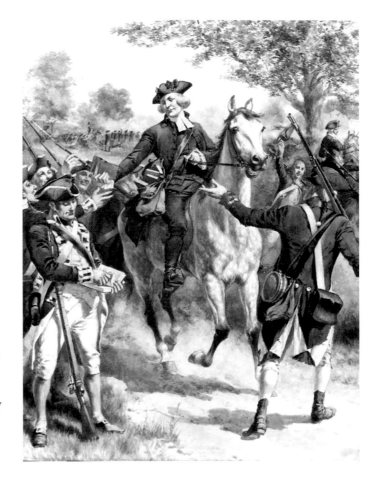

The only of seven Caldwell sons not born in Ireland. The reverend's and his wife's early deaths left nine orphans. *Henry Alexander Ogden.*

The graves of Hannah and James Caldwell still hold a prominent place at the First Presbyterian Cemetery on Broad Street in Elizabeth. *Author collection.*

Little over a year later, James Caldwell would himself be dead, shot in Elizabeth by an American sentry named Morgan. Though general agreement has resulted regarding the facts of the murder, mystery still surrounds several key issues. Who was Morgan? Was he simply doing his duty or did Loyalists or the British bribe him? Was it an accident?

Morgan was given a fair civilian trial, but should he have been tried in a military court? Was Morgan shooting at Caldwell because he blamed Caldwell for grievances in his job as army quartermaster? Was Morgan a savage, drunken Irishman who killed his own child in a fit of rage or was he an Englishman serving in the United States army who simply performed his duty overzealously? These and other questions would all involve Nicholas Murray, the second player in this act. This much is certain. James Caldwell died at forty-eight, greatly loved, esteemed and honored as a true American hero. He is remembered today with statues in Elizabeth and Philadelphia, each greatly

deserved. The town of Caldwell in Essex County is obviously named after this famous first-generation Irish-American.

It is safe to say, however, that modern New Jersey history would not continue to recognize James Caldwell to the extent it has without the effort and work of Nicholas Murray. Murray was born on Christmas Day 1802 in the townland of Ballynaskea, County Meath, the son of a farmer. Both his parents were Roman Catholic, and like Caldwell, he was destined for the church. But Murray refused and was apprenticed to a merchant as a clerk. There is another version that claims Murray's parents were rich gentry farmers and Nicholas's father died when the boy was three years old. Some information also has him born in Westmeath and even Galway.

At sixteen, after reportedly being cruelly treated by his employer, Murray set sail for America, landing in New York in 1818 with twelve dollars to his name. Soon, Nicholas was working with the Harper Brothers printers in Manhattan, where he was treated well and was almost adopted by the family. The Harpers' put Murray through school at Williams College, and he changed religion, adopting the Harper Presbyterianism. But this time, Murray had jumped at the chance to join the clergy. By 1833, he was an ordained minister and was placed in charge of the First Presbyterian Church in Elizabethtown, fifty-two years after the death of James Caldwell, when the memory of many colonial heroes was fading.

Murray served as pastor until his death in 1861, at the age of fifty-nine. In the course of his almost thirty-year public career in New Jersey, Murray was considered a widely known theologian, historian and speaker. He was a president and co-founder of the New Jersey Historical Society, a trustee of Princeton Theological Seminary and wrote much for publication, including a book on the history of Elizabethtown in 1844. Reverend Murray even visited Ireland, twice, in 1851 and again in 1860 to promote Protestantism. On the day of his funeral, all businesses in Elizabeth closed, the bells of every church tolled in concert and it is reported that over one hundred clergy wept at the service.

But Murray was not without detractors. During the course of his pastorate, Murray viciously attacked, anonymously at first, the Roman Catholic religion in a series of letters known as "The Kirwan Letters." These letters purport to explain why an Irish Catholic should become a Presbyterian, among other things. The anger in the letters is hard to miss, and before long, "Kirwan" was unmasked as Murray. This led to a series of equally hard-line responses by "Dagger John" Hughes, the Irish Catholic bishop of New York, the most formidable Catholic in the entire country. It was a one-on-one contest that the entire nation followed.

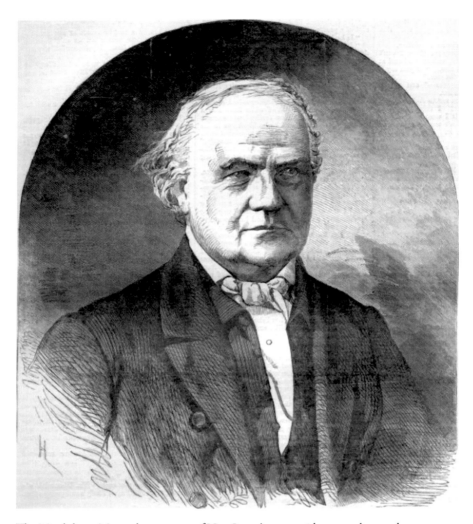

The Meath-born Murray became one of New Jersey's most strident preachers and was a founding member of the New Jersey Historical Society. *Harper's Weekly.*

But the real controversy from a New Jersey viewpoint was Murray's historical writings regarding the death of James Caldwell. Soon after the publication of his history of Elizabethtown and his work establishing and dedicating a statue honoring the great Caldwell in 1845, a letter—a very kind letter—was written by Colonel W.C. DeHart, the son of the lawyer who was assigned to defend James Morgan in the murder trial of 1781. The elder DeHart was a colonial hero and ultimately respected, and in his letter Colonel DeHart

(also a military hero, respected citizen of New Jersey, personal aide to General Winfield Scott and a member of Murray's congregation) simply questioned one or two minor points as written by Murray.

Murray went ballistic and took it personally. He attacked DeHart, his ancestry, his father, his knowledge, his education and his motives. Throughout the exchange that was played out in the newspaper, Murray became more belligerent and DeHart more civilized. It was ugly, and no objective person could help but cringe over Murray's style. When it was all over, Caldwell was still an American hero, and Murray was still a beloved pastor, but a pastor with a black eye. Murray escaped severe popular angst only because DeHart died within months of the controversy. Decades later, in 1916, evidence was uncovered that seemed to prove all of DeHart's theories accurate, including the fact that Morgan was not Irish but was born and raised in England. Morgan was hanged in Westfield on Gallows Hill, now part of Broad Street, and his last words to a procrastinating hangman were: "Do your duty and don't keep me here shivering in the cold."

Murray, who preached with brilliance and bluster, had a grandson of great note who, unlike his grandfather, won minds over with compassion and benevolence. Nicholas Murray Butler, also born in Elizabeth, became president of Columbia University, adviser to seven presidents and the winner of the Nobel Peace Prize in 1931. Both Reverends Caldwell and Murray, wonderful contributors to New Jersey history for many reasons, are buried near each other in the First Presbyterian Cemetery on Broad Street in Elizabeth.

"THE IRISH AND THE QUAKERS": THE HEALY FAMILY

OK, I admit this is a tough one. It is hard occasionally to define "Irishness," but sometimes picking a Jersey story is even harder. Some of the people chosen for this work were born in New Jersey; others died here. Some lived outside the state and commuted into our lives; for some, it was just the opposite. But all those selected made major contributions during their lifetimes to benefit the Garden State. The Healy brothers did none of the above. In this rare instance, New Jersey benefited them, and though it is a tenuous connection, we can claim part of the story as our own.

The Healy family encompasses all of the good and a lot of the bad in America. They were free, white and Irish; they were slaves, black and pieces of chattel. These Healys were wealthy landowners with many slaves, yet they became perhaps the single most prestigious religious family in the history of the United States. These Healys have become, in the last twenty years, symbols of great African American accomplishment, but not one of the eight siblings who reached adulthood admitted to being anything but white and Irish. William Faulkner could not create characters this complex. New Jersey may have played a minor role in the Healy story, but New Jersey can be proud of its involvement in this singular American drama.

It begins, of course, in Ireland, and as most Irish-Americans later find out, the first story is seldom the correct story. Albert Foley, the first Healy biographer in 1954, produced the version that the Healy children were told themselves growing up. Michael Morris Healy, from County Roscommon, joined the British army in 1812 as a sixteen-year-old. He was sent to Nova Scotia but found the war over and Nova Scotia not to his liking. He headed for Georgia and a distant cousin, Thomas Healy. After a few years of struggling in Augusta, Mike Healy ended up in southwestern Georgia, not far from present-day Macon.

In a 2002 work focusing more on the race aspect of the Healys than their history, James O'Toole comes up with a different version, and with a few more facts, thanks to son Patrick Healy's taste for genealogy in 1884. Mike Healy was indeed born in 1796 in Athlone, County Roscommon. But according to Mike's naturalization plea in 1818 (interestingly given to future president James Monroe), he was from "the parish of Kilian, in County Galway." There is indeed a parish of Killian near the border between Roscommon and Galway, and it is possible that this was the Healy parish. The naturalization records also state that Mike went straight to New York and then to Georgia. There is no mention of the British army, Nova Scotia or a cousin Tom Healy. But such stories are far from rare among the Irish in America.

Within a decade, Mike Healy had acquired a great deal of property throughout the Macon area. He had also acquired slaves and a mulatto common law wife, Eliza Clark, as law banned mixed marriages. As the years went on, Mike and Eliza became very wealthy cotton farmers with ten children, nine of whom, incredibly, reached adulthood. He had a large library, wine glasses, a gold watch and more than one hundred slaves, but he could not avoid the singular fact that his wife was also his slave. The children, therefore, were also legally slaves, and Mike and Eliza were well aware of their future.

Upon the death of Mike, all would be sold, as would Eliza. They lived lives of advantage, disadvantage and absolute fear.

Mike Healy prepared well. Starting in 1837, each child was sent north to two of his Irish sisters living in New York and trusted friends whom Mike had befriended through his business dealings. As they reached adulthood, they were to continue their educations and/or join the religious life. Healy would sell slaves to pay for the children's expenses—and if it sounds complicated, paradoxical and immoral, it was. None of the kids could ever return home without facing risk, especially after Mike died in August 1850 at the age of fifty-four. Eliza herself had died the previous May, only thirty-seven years old. The Healy will transferred all money to the children up north, and Mike, for several years, was able to pull it off with panache.

But even the best laid plans...When the first three boys, James, Hugh and Patrick, arrived in New York, no school—none—would admit them, and that is where New Jersey stepped into Healy history. Mike Healy found only one high school in the country, the Quaker Burlington Boarding School on East Union Street, that would welcome his children with open arms. Eventually, five Healys attended the school, living with local families as boarders before they moved on to fame as adults. It was not easy, for many reasons. These children were alone, first with parents they could not return home to see and then because they were orphans. In the 1840s, slavery was still allowed in New Jersey, and anti-Irish feelings were equally as rampant. But they did well in Burlington and even better later. Who were these children, and what became of them?

James Augustine, born April 6, 1830, was in the first graduating class of Holy Cross College. He went to high school in Burlington, then studied in Paris and Rome and became the second bishop of Portland, Maine. He also delivered the eulogy for his great friend John Boyle O'Reilly at his funeral. When James died in 1900 at the age of seventy, a monument was erected in his honor. James was a proper, very conservative champion of Catholicism and was revered by the church hierarchy in Rome.

Hugh Clark, born April 16, 1832, was perhaps the most brilliant member of the entire family. Hugh acted as de facto head of the family and went to Georgia, at great risk, in 1850 when his father died to bring back the three youngest orphaned siblings. Like James, Hugh went to high school in New Jersey. He was the only Healy to go into business, and by age eighteen he was handling the family money and was responsible for the care of his brothers and sisters. By today's standards, Hugh was perhaps in charge of an estate of almost $1 million. Hugh died at age twenty-one in 1853, following a tragic accident

in New York Harbor as he saw his younger brother Sherwood off to study canon law in Rome. Hugh had arranged the booking and handled financial matters for the trip, as he did for most of the family. Worried about Sherwood's going so far away, he hired a rowboat to follow the steamer out of the harbor, but he never saw another ship coming and was knocked into the water. Though saved, he developed a fever, became delirious and was dead within two weeks. It would not be the first early death of the Healy family.

Patrick Francis, born February 27, 1834, studied under the Quakers in New Jersey and also graduated from Holy Cross College. Patrick became a Jesuit priest and studied in

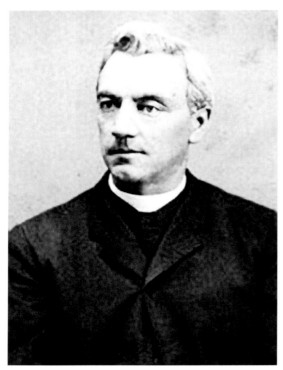

Top: James Augustine, later a bishop, was the first Healy student at the Burlington Quaker School, but he wouldn't be the last. *Diocese of Portland.*

Bottom: Patrick Healy, the future president of Georgetown University, was the third son of the remarkable Mike Healy of Roscommon and Eliza Clark. *Georgetown University Library.*

Belgium, receiving a PhD in canon law. Patrick was president of Georgetown University from 1873 to 1881, and the Healy Building on campus is named after him. He retired to Georgetown, where he died at age seventy-five. In modern times, he is celebrated as the first African American president of the college, but at no time did he consider himself anything but Irish.

Alexander Sherwood, born January 24, 1836, was ordained in the Cathedral of Notre Dame in Paris after high school in New Jersey in 1858. Sherwood, as he was known in the family, was another brilliant member of a brilliant family. A marvelous European Church scholar with a doctorate in law, Sherwood became an archbishop of Boston, where he died quietly in 1875, just shy of his fortieth birthday. More than 150 priests and church hierarchy attended his funeral, and Sherwood was considered one of the top theologians in the United States.

Martha Ann, born March 9, 1838, was the fifth child and oldest daughter. Martha studied in Massachusetts and Montreal and for a decade was a nun before marrying Jeremiah Cashman, an Irish emigrant. He was twenty-nine; she was twenty-seven. They had four children reach maturity, and except for her brother Mike, Martha was the only Healy to have children. She died a suburban grandmother at age eighty-six in 1920.

Michael Augustine, born September 22, 1839, was the last of the Healys to have a New Jersey connection. "Hell Roaring Mike" Healy was different. By age fifteen, he had run away from three schools and realized that the church—and schools—was not for him. Mike traveled (like his dad) around the world as a seaman before settling into the merchant marine as a captain in the Arctic Sea, where he became legendary. Mike spent almost half a century on the sea before he passed away at age sixty-four in 1904. He was buried south of San Francisco, in Colma, California. A United States coast guard cutter is named after him.

Eugene was the baby who did not survive after his birth on June 30, 1842.

Amanda Josephine, born January 9, 1845, was educated in Montreal. Josephine, or "Josie" to the family, traveled widely with her brothers and sisters before entering religious life as a nun, joining the order of the Sisters of the Good Shepherd. She loved life as a nun, but like others in her family, Sister Josephine died young, at age thirty-four, in 1879 in Montreal.

Eliza Dunamore was born on December 23, 1846. Like Josie, Eliza joined the religious life as a nun, entering the order of Notre Dame in 1874. As Sister Mary Magdalene, she stayed in Montreal and spoke French as her first language, eventually becoming a mother superior of the order and spending decades as a leader of her community. She died at age seventy-two after four decades of outstanding service and was buried in Montreal in 1919.

Mike Healy, shown in 1890, the last Healy with New Jersey connections, became a famous Coast Guard captain and had a ship named after him. *U.S. Coast Guard Collection.*

Eugene, born January 23, 1849, was the second Eugene and was barely twelve when the Civil War began. He was educated at Douai in Europe but found no calling for religious life, like most of his siblings. If there was a contrarian of the family, it was Eugene. He died in March 1914 at age sixty-five. He had married, but no one knew his bride. His last contact with his family was well before 1900.

The Healys were certainly the most prodigious religious family in American history. Of course, the study of the Healys is an Irish one and an African American one, though every Healy professed in his or her lifetime to be white and Irish. But their color cannot be ignored, and in the last twenty years they have been championed as great African Americans, something they would have found very strange. Slavery and the Irish diaspora came together, at least this time, to create a fabulous story, and New Jersey, especially the Quakers, played a minor but very important role. There is one school in the entire United States named after a Healy, and fittingly it is in New Jersey. The Patrick F. Healy Middle School of Printing and Publishing serves children in East Orange interested in creative writing and arts. Mike and Eliza Healy would surely be proud.

"The Mo-Town Confederate": Reverend James Sheeran

James Sheeran is not the only Confederate buried in New Jersey, but he is the only known Rebel chaplain interred in Jersey soil. Sheeran, one of seven children born in Longford Town to Fearghal and Rose Sheeran, was a walking Irish diaspora all by himself. His immigration pattern reads like that of a roadie on a Springsteen concert tour.

Sheeran left Longford, according to oral tradition, by himself. He landed in Quebec, lived in New York, married and fathered children in Pennsylvania and Michigan, worked as a tailor and teacher before becoming a priest, served the Louisiana Tigers as a chaplain, hated Yankees with an unmatched passion and eventually thrust himself into New Jersey life. His story, from the bog to Morristown, is remarkable, and much of what is known has been portrayed inaccurately.

Jim Sheeran's journey began in the parish of Templemichael, County Longford. American records vary, but newly discovered Irish records reveal that the future pastor was born in 1817, and his family lived at Great Water Street. At age twelve, Sheeran immigrated, supposedly alone, to Canada, which was the cheapest ticket to North America. Sheeran never mentioned his family in print, though late in life he employed his cousins as housekeepers in Morristown.

Sheeran worked in Quebec for a couple of years before moving south to New York City at age sixteen; he stayed in the Big Apple for two years. According to

Even late in life in New Jersey, Father Sheeran, a pioneer pastor in Morris County, carried himself in a military manner. *Author collection.*

Father Sheeran's obituary, he taught Sunday school at St. Mary's on Grand Street, perhaps a hint of his future calling. Soon, in what would become a pattern, Jim moved, at age eighteen, 240 miles southwest to McConnellsburg, Pennsylvania, the cultural opposite of New York. McConnellsburg, a tiny village then and now, lies 40 miles west of Chambersburg, where Sheeran would begin his adult life as a tailor.

McConnellsburg is nestled in the Kittatiny Mountains, originally settled by Irish immigrants later mislabeled as Scotch-Irish. Towns surrounded the area with names like Belfast, Lurgan, Dublin, Letterkenny and Antrim. Here, James Sheeran fell in love and married Margaret Graham. In his later pastoral life, Sheeran's married life is left out, and his lengthy obituary, written with no small assistance by the Catholic Church, omits it entirely.

Jim Sheeran, this time with Margaret, picked up and left after just a few years, soon after the March 23, 1843 birth of their daughter, Isabella. They ended up four hundred miles north in Monroe, Michigan. It must have been a sudden move, as Isabella was not even baptized until late 1845 in Monroe. That same month, Jim and Margaret became parents to their only son, Sylvester, who lived only four months and was buried in Monroe.

How and why Sheeran chose the places of resettlement we will never know, but Monroe was not selected because of anything Irish. The town was originally a French colony before being named after President James Monroe. In Monroe, Sheeran's life changed dramatically; first, he became a widower when Margaret died in 1849 at age twenty-eight. He then placed Isabella at St. Mary Academy, a boarding school run by the sisters of the Immaculate Heart of Mary (IHM), an order founded right in Monroe.

Jim Sheeran entered the public stage, editing a local paper and becoming a correspondent for the famous Irish weekly, the *Freeman's Journal*. It was around this time—1851 or so—that he also turned from tailoring to teaching at a boys' school run by the Redemptorist order. In 1853, at age thirty-six, James Sheeran, schoolteacher, made the momentous decision to become a Catholic priest and entered the Redemptorist novitiate. Four years later, at age forty, he was ordained Father James Sheeran and assigned to New Orleans. His daughter, Isabella, also entered religious orders and departed for Pennsylvania as a teaching nun in Reading.

By all accounts, Father Sheeran spent his first three years in New Orleans adapting very well to his vocation and the Louisiana lifestyle. When the Civil War broke out in 1861, Father Jim leaped at the opportunity to serve the Fourteenth Louisiana Infantry, commonly known as the Louisiana Tigers. Now forty-four, the personality of the Longford man began to take public

shape. He was said to "hate Yankees" and called them "Lincoln's bandits." Another observer said that Sheeran "was not a man to submit quietly even when convinced of its absolute necessity."

The Reverend Jim Sheeran was, in effect, just like his ferocious Tigers— "ever ready to do battle." One has to wonder if these attributes shown by Sheeran had always been in his tailor and schoolteacher's body or appeared like St. Paul, after a thunderbolt. Whatever the reason, Father Sheeran served four years in the field while writing in his journal, waging war on drunkenness, profanity and gambling. He was not a man to trifle with, and according to many witnesses, he was absolutely fearless.

No shrinking violet, Sheeran verbally took on officers when he believed it was necessary, and even generals were not exempt from his wrath. When General Stonewall Jackson told the little priest, "Father Sheeran, you ask more favors and take more privileges than any officer in this army," the former tailor turned priest replied, "General Jackson, I want you to understand that as a priest of God I outrank every officer in your command—I outrank even you!" Jackson, a severe anti-Catholic, stared in astonishment and, without speaking a word, left his own tent. Two stone walls head to head. It must have been fun to watch.

Sheeran exasperated General Jackson some time later, and this time Jackson got even. The chaplain interrupted a staff meeting with a suggestion that Jackson could do "so and so" in an upcoming battle plan. Stonewall turned his steely gaze directly down at the smaller man and said, "Who will be responsible for this battle, Father Sheeran or General Jackson?" This time, it was Sheeran who quietly left the tent.

On November 4, 1864, Father Sheeran was arrested by Union forces and sent to Fort McHenry as a prisoner of war. After a short but typically volatile stay, Sheeran was released, but not until he demanded free passes from General Phil Sheridan himself—and got them. The stern, uncompromising and at times cantankerous and irascible priest certainly lacked gentle virtues, and his patience could not be improved with the carnage he saw during the war or with the news in 1862 that his daughter, Isabella, had died suddenly at age nineteen in a Benedictine convent.

At war's end, 115 chaplains had been killed in the Civil War, but Sheeran returned to New Orleans alive and well. He worked there until 1867, including duty above and beyond during the New Orleans yellow fever epidemic, which killed thousands. Father Sheeran was now fifty—a tough, hardened fifty—and any normal observer would think him ready to settle down in his adopted hometown.

Why we will never know, but once again, Jim Sheeran was on the move, requesting and being granted a leave from the Redemptorists. He headed initially for Detroit but, in 1871, was in the New York area, where he tendered his services to the Diocese of Newark.

Though initially skeptical, Archbishop Bayley offered him a parish in the middle of nowhere—Morristown—which no one else wanted. To the surprise of Bayley, and maybe James Sheeran himself, the old chaplain stayed ten years, a longer stint than he had logged at any one place in America. Father Sheeran, still stern and unbending, would make Assumption Parish the pride of Morris County.

He oversaw the building of a new church and school and arranged for the purchase of a much-needed Catholic cemetery.

The passionate zeal Sheeran brought to his parishioners was reciprocated, for the most part, though he continued to attack problems head on. At least twice, his boss, Bishop Mike Corrigan, held meetings at Assumption "to pour oil on troubled waters." Usually, with the Longford parent turned pastor, it was his way or the highway.

Sheeran was even given a vacation trip back to his native land, the first time he had seen Ireland since he left at eleven years old. Assumption Parish is still a standard-bearer of Catholicism in North Jersey, thanks in great measure to the

The grave of Reverend James Sheeran, the only Confederate chaplain buried in New Jersey. *Author collection*.

vision of the County Longford immigrant. His assistant, the Reverend James O'Flynn, a veteran of the Thirteenth New Jersey Infantry, replaced Sheeran. Dinner at the rectory no doubt was interesting.

Father James died on April 3, 1881, and is buried in the Holy Rood Cemetery he created in the state where he chose to live the last decade of his life. He was indeed a peregrine, a Gaelic wanderer, like so many of the diaspora, but at the end of the day, he was a Jersey guy.

Patriots in a Civil War

"The (One-Armed) Jersey Devil": Phil Kearny

Phil Kearny, one of the better known but misunderstood New Jersey Irish-Americans, was born in New York City. Kearny was mistakenly called by his enemies "an Irish bog trotter," mislabeled "loosed out of Ireland by the Potato famine" and even ridiculously called "that rabid papist." In truth, Kearny was a solid Methodist and the progeny of a wealthy family from New Jersey since 1704; he was given $1 million by his grandfather when barely out of his teens.

Phil Kearny was, for sure, the greatest soldier ever to call New Jersey home. He fought in five wars and was respected and remembered by winners and losers of all five. He had a New Jersey town and two military decorations named after him. General Winfield Scott called Kearny "the bravest of the brave." General George Halleck said, "A braver man never lived. His loss to our army cannot be repaired." When asked by his most detested enemy, George McClellan, if he could lead his men to an objective during the Peninsula Campaign of 1862, Kearny shot back, "General, I can make men follow me to hell."

The French dubbed him "Kearny le Magnifique" and pinned the Legion of Honor on his lapel. After he was killed, Confederate general A.P. Hill, who knew him well, said, "Poor Kearny! He deserved a better death than that!" He surely did. But his life, though short, was, as the French recognized years earlier, magnificent. Phil Kearny had great enemies but even greater friends. He was an Irish-American and a Jersey guy.

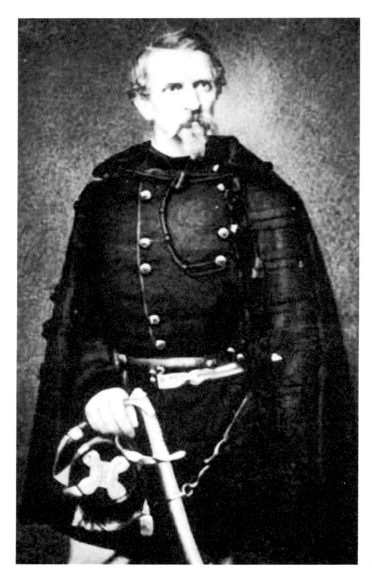

Phil Kearny, the greatest military figure in New Jersey history, was a descendant of Gaels from County Cork in the seventeenth century. *Newark Public Library.*

Phil Kearny was a descendant of Michael Kearny, who settled first in Shrewsbury and then made Perth Amboy the family seat for generations. Mostly businessmen, the Kearnys married well and made money even better. Phil's father and grandfather were both founding members of the New York Stock Exchange. When Kearny's mother died when the boy was eight, his grandfather, John Watts, basically raised him, though tutors, boarding schools and servants were a constant.

Phil Kearny yearned as a boy for only two things: horses and the military. He never went to West Point, though some biographers have said he did, but he was on horses constantly and begged to enter the military. His father and grandfather denied him and attempted to push him into the Episcopal ministry. One can only imagine that! A brief compromise of law school was agreed on, but Phil was miserable.

But the dutiful grandson toiled away at clerkships and banking jobs until September 3, 1836, when John Watts died and left our barely twenty-one-year-old Kearny $1 million—an incredible amount in those days, perhaps $50 million in today's market. Almost immediately, Phil Kearny joined the United States Army. Within six months, he was commissioned a second lieutenant in the U.S. Dragoons, with help from his uncle, Stephen Watts Kearny, himself a future legend.

In less than a year, he was sent to France to learn cavalry tactics, and like the ultimate man of action he was, he soon was in Algeria fighting the Arabs. While there, he fought in the French "chasseur" style—sword and pistol in hand and reins in the teeth. It was here he earned the nickname "Kearny le Magnifique."

Upon returning to the States, Kearny was based in Carlisle, Pennsylvania, and met and married the lovely Diana Bullitt, a strong-willed woman from Missouri. They lived in Washington, and Diana had four children in four years. Kearny the soldier was unhappy but resigned from the service at his wife's request. But if Diana was strong willed, Phil was iron willed. Kearny rejoined the cavalry as soon as the Mexican War began and raised his own company.

It was during this period that Kearny purchased a huge tract in Newark and built an estate he called Bellegrove. It was later to be incorporated as a city and named Kearny after our general. Again, as proof of the Irish heritage of the Kearnys, the civil survey of Bellegrove was called the "Irish Tract." Frederick Law Olmsted, who also designed Central Park, designed the grounds—additional proof of Kearny's wealth.

In Mexico, Kearny's men were considered the best, and Scott made them his personal escort. In a scene to be fully brought out, Kearny led his men in a furious charge at the Battle of Churubusco to the very gates of Mexico City. It was here that Kearny lost his arm, most of his men and almost his life. His absence both during and after the Mexican War led Diana to leave him, taking the children back to her family home in Kentucky. Kearny responded in 1851 by joining his regiment in California during the gold rush and fighting Indians. Disillusioned, Kearny resigned again and headed back to Europe.

In Paris, our mercurial man of action fell in love with an eighteen-year-old, and because Diana would not divorce him, he installed Agnes Maxwell, his

Called by General Winfield Scott "the bravest man I ever knew," this equestrian statue of Kearny is one of only two at Arlington National Cemetery. *Arlington National Cemetery Collection.*

new love, in Bellegrove, where they lived as man and wife—a major scandal. Neither Agnes nor Phil Kearny cared a whit, but they paid a price. After a few years of pleading for a divorce, Diana relented, and Agnes and Phil were married in 1858. They returned briefly to Paris, where Phil offered his services to the French during its war against Austria.

Soon, however, civil war beckoned, and like most career American soldiers, Kearny was torn. He was a Union man and—unusual for most—an early abolitionist. But he had deep friendships with many Southern soldiers and in fact fought in France with John Magruder. Phil returned home to Bellegrove—soon to be named Kearny in his honor—with Agnes and his new family. After fighting several political skirmishes, mostly because of his scandalous arrangement with Agnes prior to 1858, Kearny was appointed brigadier general of the First New Jersey.

He was a shining star, almost a meteor, the first year of the war. He turned down a chance to become a division commander for McClellan, a man Kearny professionally despised, to stay with his New Jersey boys. At Chantilly, on

September 1, 1862, the man who had fought so bravely in five wars recklessly tried to escape a line of pickets, only to be shot and killed on his horse. He fell, kicked once and was dead. Confederate lore has it that an Irishman, John Crimson of the Forty-ninth Georgians, shot the dashing Kearny. A month before, Kearny had written, "In a space of not many years, I have lived a fearfully long lifetime." He was buried at Trinity Church in Manhattan before being removed to Arlington National Cemetery in 1912.

"The Man Who Would Be King (of Sussex)": Hugh Kilpatrick

Sussex County may be the most beautiful county in New Jersey. The land has definition, and indeed, its rolling hills and hidden glens are the closest to resembling parts of Ireland, especially parts of Wicklow or Antrim, that you will find in New Jersey. It even has a river, the Wallkill, which runs north. Nonetheless, Sussex Borough, in the northwestern corner of New Jersey, will never be considered an Irish enclave, and if truth were told, it is still not much of any enclave. In the 1840s, there were only four stores and a population of fewer than five hundred people in its sixty-two square miles running uphill toward Milford, Pennsylvania. Today, even as New Jerseyans are exploding westward out of Bergen, Passaic and Hudson Counties, the borough has a little over two thousand people and no police department. In a strange modern twist, however, the community has formed a Sussex branch of the Guardian Angels. The Crips and Bloods must be terrorizing the cows or congregating near the three stoplights in the middle of town.

But the Irish, as any traveler the world over knows, are everywhere, even in Sussex Borough. Sometime in the early eighteenth century, Ephraim Kilpatrick (in Irish, "Patrick's Church") arrived in Sussex, then called Deckertown. Oral history makes Kilpatrick perhaps the first Irishman to settle permanently in Sussex. He carved a farm out of the hillsides along what is now County Route 650 and married a descendant of Peter Decker, the first white settler of the area and founder of the borough that for years bore his name. Little is known of Ephraim's life, except that his son, Simon, married a young woman of Dutch ancestry, Julia Wickham. The Wickhams were originally from Massachusetts but left there to settle in Sussex after the War of Independence. Julia's father, William Wickham, was slashed in the head as a baby when British troops

ravaged his village. Perhaps it was that story, or the fact that his father, Simon, was a colonel in the New Jersey militia, that made our subject, Hugh Judson Kilpatrick, so determined to be a soldier.

There was another Hugh Kilpatrick, as well, who fought for New Jersey in the Revolution. Was this perhaps Ephraim's brother? It certainly would explain Simon not naming his son after himself or even after his own father. But it was Hugh Judson's complex desperation that has put Kilpatrick in the history books, a desperation that also made him a figure to be pitied.

Hugh was born on January 14, 1836, on the family farm in Deckertown. The Kilpatricks were people of modest means, and Hugh grew up locally. When he was just a boy, he decided that farming was not his future. Was he rebelling against his dad? There is no direct proof, but throughout most of his life, Kilpatrick talked about his mother with loving regularity, but never his father. Whatever the reason, Kilpatrick, by his mid-teens, was already

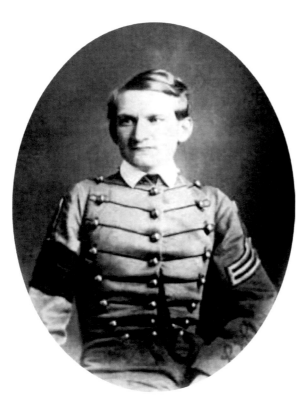

plotting out his life in politics and the military. Hugh, or Judson, as he preferred most of his life, was stumping all over West Jersey before he was twenty for a local congressman. Kilpatrick wanted desperately to be a West Pointer and knew his modest background would never get him accepted. After rejection the first time around, Hugh angled early for influential sponsors—a tactic he never abandoned. It didn't hurt that the congressman won, and Kilpatrick, despite his lack of means and advanced education, was admitted to West Point soon after.

Hugh Judson Kilpatrick at West Point. *Wayne McCabe Collection.*

West Point was a perfect microcosm of Kilpatrick's later life. He made a few loyal friends and more enemies, and the chip on his shoulder because of his physical appearance made him tough but very rash. Both qualities would define Kilpatrick the rest of his life.

Hugh was certainly, like many other men of the Civil War generation, a study in contradictions. In an era of soldiers who gambled excessively, he never did. Kilpatrick preached against drinking, but he didn't practice what he preached. He was renowned for his adultery and lacked almost all integrity. Kilpatrick was small, even by nineteenth-century standards. He was described by one of George Meade's staff as "a wiry, restless, undersized man with black eyes and a lantern jaw." He sported "huge sandy-colored sideburns on this small, rather ugly body, with bandy legs...and he spoke in a shrill voice."

Yet overlooking Hugh Judson Kilpatrick would prove to be a mistake to many. He was relentlessly ambitious and fearless and predicted a major generalcy for himself. He truly believed that if he survived the war, he would become governor of New Jersey and then, inevitably, president of the United States. In short, he was either a visionary or nuts.

His Civil War career was typical Kilpatrick. His self-promotion enabled him to acquire good commands, but he embroiled himself in failure. At least five different times in the course of the war, Kilpatrick failed in schemes he thought might advance his career. Kilpatrick was called "Kill-Cavalry," not, as some of his biographers suggest, because he had horses shot out from under him but because he was reckless with his men's lives, the Lord Mountbatten of the Civil War. He was jailed twice, once for selling provisions for personal profit and a second time for defaming government officials when drunk in Washington.

Kilpatrick did not distinguish himself at Gettysburg, and to replenish his reputation, he concocted a scheme to invade Richmond with his cavalry and capture Confederate officials. Lincoln was so desperate for success that he approved the plan, and Kilpatrick led four thousand men south in February 1864. The raid was an utter failure, and Kilpatrick thought his future was finished. Only Sherman saved him.

There are great stories regarding Kilpatrick's fearlessness. There are just as many suggesting cowardice. In the end, he finished the war as Sherman's attack dog on the March to the Sea, where he was appreciated for what he was by Sherman. "I know Kilpatrick is a hell of a damned fool," said General Sherman, "but I want just that sort of man to command my cavalry on this expedition." As a result of his actions with Sherman, he ended the war a brevet major general.

Kilpatrick in the field during Sherman's March to the Sea, 1864. *Wayne McCabe Collection.*

He was appointed as ambassador to Chile because of his postwar political work. Besides his career in politics, Kilpatrick spent several years on the lecture circuit across the country. Kilpatrick did very well financially, until he gave a lecture on the "Irish Soldier in the War of the Rebellion." Though well received by Irish audiences from Boston to Cincinnati, Kilpatrick dropped it quickly when he realized that most of the country was still anti-Irish, even after the war.

There is also ample evidence that Kilpatrick allowed his farm in Sussex Borough (Deckertown) to be used as an arms cache for the Fenians in the invasion of Canada in 1866. Kilpatrick's relationship with the Fenians and General John O'Neill of Elizabeth cannot be denied.

Kilpatrick's personal life is just as convoluted as his military career. He married twice. When his first wife, Alice Nailer, died in 1863, he lived the life of Warren Beatty, despite looking like Woody Allen. His amorous lifestyle also caused him problems throughout the rest of the war, including one woman

who shared him with the newly married George Armstrong Custer, and twice he was almost captured by Confederate cavalry when he was with prostitutes.

His second marriage was to a wonderful Chilean woman, the niece of the archbishop of Santiago, soon after Kilpatrick was appointed ambassador to that country. Even then, Kilpatrick surrounded himself in controversy. On the long voyage to Chile, Kilpatrick traveled with a married woman and presented her initially as his wife. Embarrassingly, after he dropped the pretense, the woman took to the streets of Valparaiso as a prostitute. After returning in 1868, he lived a retired gentleman's life, mostly in Sussex Borough. Kilpatrick also held a huge 1878 Civil War reunion at his farm, which was a combination Roman circus and modern day reenactment, with forty thousand people from all over the tri-state area.

He ran for public office once—congress in his beloved New Jersey—but was crushed at the ballot boxes, possibly by voters who remembered how easily Kilpatrick had sacrificed his men in battle for his own glory. After switching parties twice, he again was appointed ambassador to Chile in 1880. He died in Chile less than a year later, at the early age of forty-five. Kilpatrick, who yearned his whole life for adulation, had to settle for reburial in West Point and a small monument dedicated in 1901. His Chilean wife, Rosa, died in Santiago in 1926. The local Sussex County paper finished his obituary with the words, "When centuries shall have sped and a grateful posterity shall turn the leaves, no name will inspire a higher admiration for valor, or a deeper devotion to country than Hugh Judson Kilpatrick." Even in beautiful Sussex County there can be found extreme exaggeration, and the suspicion that Kilpatrick himself wrote the sentence would surprise few.

On a brighter side, one of Hugh's granddaughters, Gloria Morgan, married Reggie Vanderbilt, and the famous Gloria Vanderbilt is his great-granddaughter. Gloria's sister, Thelma, introduced her friend Wallis Simpson to Edward, the Prince of Wales, and we know how that ended. Hugh Judson Kilpatrick, no doubt, would have been very proud.

"The Final Resting Ground": Finn's Point

Not all the Irish who have made New Jersey their final home were pleased about the choice. In truth, there was no option for the hundreds of Irish and Irish-Americans who lie buried in Finn's Point Cemetery, Salem County.

Finn's Point Cemetery on the grounds of Fort Mott. The obelisk was erected in 1910, forty-five years after the war. *Author collection.*

They were "Johnny Rebs," Confederate soldiers who, in the course of the Civil War, were captured and sent to POW camps in the North. Probably not one of these sons of Erin and the South ever spent a single minute alive in New Jersey. But, except for summertime on the Jersey Shore, they may constitute the largest single Irish gathering in southern New Jersey.

Finn's Point, New Jersey, has been settled since 1638. The first Swedes and Finns landed in Delaware but, like most folks since then, quickly realized that New Jersey was a better place to be and migrated across the Delaware to what is now Salem County. Finn's Point Cemetery is located in an alcove of Fort Mott, now a state park just a few miles south of the Delaware Memorial Bridge. It is a long way from Georgia, Arkansas and Louisiana and even farther from Ireland. In 1860, young boys from all those places dreamed of many things, but they never dreamed of being buried in a tidal marsh section of New Jersey.

You can visit Fort Mott, stand on its ramparts, look west and see tiny seventy-five-acre Pea Patch Island, site of Fort Delaware, the place these boys and men died between 1862 and 1865. Not just a few died either. Twenty-five hundred, at least, perished in this place Southerners hated with a passion. But since the victors write history, Fort Delaware is generally a footnote in

American history, while Andersonville is the subject of dissertations, books and movies.

The masonry fort was originally built just prior to the Civil War as a defense for Philadelphia and the mid-Atlantic region. Though it belongs to the State of Delaware, a mile west, Fort Delaware is actually closer to New Jersey. When the war began, the War Department panicked and garrisoned the fort, in case of need, against the Confederate navy, especially since Maryland and much of Delaware were pro-secession. But by late 1861, this threat had dissipated, and Pea Patch Island became home to POWs instead.

In April 1862, the first large contingent of prisoners, 358 men captured at the Battle of Kernstown, Virginia, arrived. In less than four years, the fort interred between twenty-two thousand and thirty thousand soldiers and officers (record keeping of POWs on either side was not a big priority). Soon, Confederate prisoners were pouring in from both Virginia and the western front in Tennessee. At times throughout those four years, there would be more than eight thousand housed on this six-acre fort.

It wasn't long before Fort Delaware became known as "the Andersonville of the North," as well as "Fort Delaware Death Pen." Of all the Union prisons, it had the absolute worst reputation for cruelty and the highest mortality rate. Disease was rampant, food was poor and scarce and each man was allowed one blanket or one overcoat—not both. Two rain barrels provided the only water for inmates, one at each end of the barracks.

The result was obvious. Officially, we know the names of 2,436 Confederate POWs buried in the Garden State, but most agree that there were perhaps hundreds more, many of whom never made it to burial grounds. But how did they end up in New Jersey? The water table was too low on Pea Patch, so all bodies were rowed the half mile to the closest land—Finn's Point. There, all bodies were buried in mass graves. In the ensuing 150 years, the cemetery, with ten-foot-high sea grass, enclosure walls and cedars surrounding the single-lane approach from Fort Mott, has become one of the most bucolic and serene sites in New Jersey.

Every state in the Confederacy is represented, but perhaps the most chilling statistic involves the Battle of Gettysburg. The conclusion of that three-day battle, with more than fifty-one thousand American casualties, saw the awful, almost suicidal charge of General George Pickett's force across the Wheatfield and Emmitsburg Road. In that last hour, perhaps five thousand men died, mostly Confederate. Imagine that hellfire attempt and, somehow surviving, being taken prisoner, thinking the worst of the worst was over. But it wasn't, by a long shot. Almost all the Gettysburg POWs were sent to Fort Delaware,

where they died in great numbers of wounds, disease and mistreatment. Then they were buried in common graves in a place they may have never heard, Finn's Point.

Charles O'Brien was born in Ireland and enlisted in the Fifteenth Louisiana Infantry; Joe Flynn, James Teague and Willie Kennedy all fought for Georgia; while Alex Fox, James Murray and William Murphy enlisted in North Carolina Infantries. Each was captured at Gettysburg during Pickett's Charge and sent to Fort Delaware, where they died of fever, smallpox and typhoid. The only record of their burial is the common phrase, "Buried on the Jersey shore." They joined 2,429 others with similar tales of woe.

Following the war, ex–Confederate general James Kemper, then the governor of Virginia, complained about the neglected condition of the remains at Finn's Point. As a result, Finn's Point National Cemetery was established, and in 1879, the U.S. government erected a marble monument to the 135 Union soldiers buried there. There was still nothing to mark the graves of the Confederates. That changed only in 1910, when an eighty-five-foot-high obelisk was built, with the names of the known dead from every Southern state inscribed. Ironically, the monument is made of white granite from Pennsylvania, where so many had been captured at Gettysburg.

How many were Irish or Irish-American? There is, of course, no exact answer. But studying the list of names gives up some quality information. There are easily more than two hundred pure Gaelic surnames, including:

Ard	Delaney	Mayo
Brady	Donnelly	Meehan
Brogan	Dooley	Murphy
Cahill	Foley	O'Brien
Callahan	Harrigan	O'Connor
Connell	Hickey	O'Neal
Conner	Higgins	Owens
Cormack	Kelly	Riley
Corrigan	Kennedy	Ryan
Daughtery	Mahon	Sullivan

Additionally, there are approximately another 150 common surnames found throughout Ireland for a thousand years, including:

Barry	Hughes	Moffett
Bonner	Holland	Moore
Darcy	Kirkpatrick	Mullen
Fadden	Madden	Murray
Fox	McGinty	Tracey

Of course, there are several hundred more who could easily be Irish, but certainly a percentage would have to include:

Barber	Collins	Mitchell
Barton	Davis	Morris
Belew	Ford	Morrison
Bratton	Gowan	Smith
Brown	Green	Tully
Caldwell	King	White
Carleton	Mangum	

Last, but certainly not least, would be what we could call the Ulster Irish—the revisionist phrase might be Scotch-Irish—who also figure prominently:

Armstrong	Ferguson	McCallum
Campbell	Johnson	McDonald
Cosby	Martin	
Courcey	McAllister	

Conservatively, Irish-Americans make up 20 to 25 percent, at least, of the Confederate dead at Finn's Point—a strange twist to history and thoughts to ponder as you drive over the Delaware Memorial Bridge on the way south.

A sad footnote: Finn's Point Cemetery was the scene, in 1997, of the random murder of Mr. Bill Reese, caretaker of the cemetery. He was killed by mass murderer Andrew Cunanan, who ultimately died after killing fashion mogul Gianni Versace in Miami. It was Mr. Reese's pickup truck that Cunanan used to escape to Florida. Mr. Reese was a gentle soul, active in Civil War reenacts. There is a plaque at the cemetery in his honor. There was so much unneeded death at one of the most peaceful and hard-to-find sites in all of New Jersey. If you care about the Civil War, or the Irish, or the South, or New Jersey or America, you should visit.

Builders and Businessmen

"The Forgotten Chosen Ones": Canals and Pubs of Old

Some Irish came to New Jersey as unknowns and remained so, the forgotten chosen ones. They began arriving as early as the 1600s, landing in South Jersey to escape two vicious wars in that century in their homeland. They were small groups searching perhaps for the Land of the Young, *Tir na Og*, where, in their dreams, they might find a place where sorrow, decay and death are gone. But they left us no memory of their Irish myths and no record of their presence, save a rare place name. Others came in the 1700s, this time often as single men hired as teachers or indentured servants. But the largest group of unknown Irish immigrants to New Jersey came to build two canals, first the Morris and then the Delaware & Raritan (D&R).

The Morris Canal came first, with digging starting in 1825. The 102-mile canal from Phillipsburg to Jersey City was completed to Newark in 1831 and then to Jersey City in 1836. When it was finished, the incredibly successful Morris overcame more elevation changes than any canal in the world. At its peak, in 1866, the Morris Canal carried almost a million tons, including half a million tons of coal. When the railroad leased the canal land in 1871 (for ninety-nine years) along the waterfront, the Morris was soon doomed, and by 1924 it had become totally obsolete and was drained. The majority of the canal became sewers, water lines and even the Newark

The Morris Canal was the world's biggest hill climber and traversed 102 miles, from the Delaware to the Hudson. *New Jersey Archives.*

City Subway. Today, there are small parks in seven localities, but not much else marks its existence.

All experts, without exception, agree that it was the Irish who built the canal. They were most often recruited by subscription in Ireland and often in gangs in America. Newark's Irish population soared for the first, but not the last, time, with workers looking for work on the Morris. The work itself was, as the late, great, Irish-American historian Dennis Clark said, "arduous beyond belief...so grueling and dangerous was the work that Irishmen, considered less valuable than Negro slaves, were used at times in preference to an investment of black labor." This adds credence to the famous black slave quote from Jamaica a century earlier: "If there were no Negroes, Irish would be Negroes of the world." How many left homes and families in Newark (or Dublin) for months or years for less than a dollar a day is forever unknown, but there are plenty of small cemeteries like the one on Old Mine Road in Netcong that silently testify to the presence and death of the Irish along the route.

The D&R soon followed, with merchants eager to emulate the Morris but with goods traveling between the Philadelphia market, through Trenton and

New Brunswick to New York. The D&R was forty-four miles, and digging began in 1830 before it opened in 1834. As with the Morris, 1866 was a big year, with the canal carrying more weight in goods than the more famous Erie Canal ever carried in any year. But the railroad again intruded, and by 1893, the D&R had stopped being profitable. It officially closed in 1932.

Once again, it was the Irish navvies who dug the canal. Though early Americans were no strangers to hard work, the digging of the canals by hand with axe, pick and shovel was a different ballgame. It was so brutal that workers were often recruited from Ireland; even the hardy Americans and Irish-Americans wanted little of the opportunity. It was, as the Irish-born Philadelphia newspaperman Matthew Carey said in 1831, "ungodly and unholy employment." Hundreds more died, all lost to history, from cholera, typhus and broken hearts. Especially in 1832, when a cholera epidemic struck the D&R—in particular, the Princeton area—few of the hundreds of dead Irishmen had family in this country, and they were silently buried in or at the edge of the canal itself. Bull Island, just north of Stockton on the Delaware, has a reputed large mass grave of Irish. In Griggstown, there is a wonderful remembrance to twelve Irish canal workers' graves, discovered only a decade ago and kept up by a local AOH. In New Orleans, the number of twenty thousand canal dead, mostly Irish, is seldom disputed.

In the *Encyclopedia of New Jersey*, there is not a mention of the Irish in entries of either canal, and in the entry for the Irish, there is the following one-sentence notation: "Irish labor was largely responsible for the building of the Morris Canal in the 1820s and the D&R in the 1830s." The wonderful encyclopedia, long awaited, ended with the patronizing statement, "Precisely as industrialization gathered speed in New Jersey, a ready supply of Irish brawn—and sometimes brain—arrived to help it along."

Today, though there is not much left of the canals, a day-tripper can still follow the terrain carefully and glean an awful lot of lost New Jersey memories. The Morris is more difficult because of roads and construction, but the Morris Canal Society has done wonderful work reconstructing its history. The D&R is shorter, more flat and bucolic as it wends its way through a much less populated area of central New Jersey. Speckled throughout both canal routes, from Phillipsburg to Jersey City and Trenton to New Brunswick, are remnants of places the Irish are famous for—pubs.

It was in such places that the navvies, pole men, lock supervisors and their families would congregate as they have for centuries, both here and in Ireland. In Irish conclaves, both past and present, the visitor can find along the route of the canal pubs where known and unknown Irish spent precious time. Wharton,

Billy Briggs was the iconoclast pub owner with a deep and sincere love of Ireland who made Tir Na Og perhaps New Jersey's most traditional Irish tavern. *David Gard Collection.*

Paterson, Newark and Jersey City all had Irish pubs along the Morris Canal, and Trenton, Princeton and New Brunswick pulled many a pint. These are not "plastic paddy" pubs, with green beer in plastic cups or cold Guinness and "When Irish Eyes are Smiling" on the box; there are no Notre Dame banners, either. Pubs that don't have to scream out "Irish!" just are.

We're talking about an old-time Irish pub. A bit dark and dusty, with county or local athletic banners, a pool table and a cacophony of conversations drowning out the TV—if there is a TV. A bartender without cufflinks, an occasional crooked table and a like pol sitting at it and history, with framed newspaper articles and black-and-white photos with stories to match. There are not many left, and soon they will go the way, not of the buffalo, but of the canal. But finding such a place is as joyful as walking along the D&R in Rocky Hill on a spring morning or resting along the Morris Canal at Waterloo Village in summer.

Jersey City has Dorian's and Brennan's in Grenville; tiny Wharton has the Irish Rose and the Trinity Pub. New Brunswick has McCormick's; Elizabeth, Nugent's; and Newark, the indomitable McGovern's. But the one with a feel for the most history is arguably Billy Briggs's Tir Na Og in Trenton. One corner in a back alcove gives an idea of how much Billy understands about Irish

and Irish New Jersey history. Sure, it has the obligatory 1916 proclamation, pictures of Pearse and Collins (not too many Irish-American pubs are Dev fans) and other wonderful items, but in one small corner are eight Irishmen with New Jersey ties.

Wolfe Tone is there, and for two years this unforgettable nationalist lived in Princeton. Tone left New Jersey in 1796, but he left behind his wife, who was just as committed to his ideals as anyone in Ireland. Wolfe Tone, buried in Bodenstown, County Kildare, also left a son in New Jersey, William, who was born in 1791.

James Connolly is there, too. Connolly and his poverty-stricken family lived for several years in Newark while he worked at the Singer Sewing Machine factory in Elizabeth. In September 1903, Connolly immigrated to America, where he worked as an insurance collector. Later, he would be fired from Singer's as a communist agitator.

James Turner is below Connolly, but not because he was less a patriot. Turner was an attorney from Jersey City who arrived in the United States in 1849 and became a lawyer in 1859, just prior to the Civil War. Turner, as did many Jersey guys, joined the Eighty-eight Regiment, which became part of the Fighting Sixty-ninth Irish Brigade. In addition to being a fighting soldier, Turner, son of a County Louth man, was also a renowned writer during the war. Turner became a captain with the Irish Brigade in 1864. He was shot in the head and killed at the Battle of the Wilderness. He was buried in Jersey City and left a wife and child.

John Devoy was a Billy Briggs–type guy. Devoy spent much time in New Jersey and died in Atlantic City. It was September 29, 1928, and the grand old fighter was eighty-seven. After a funeral mass in New York, he was interred back in the mother country. A recent biography of Devoy by Terry Golway, *Irish Rebel*, proves him to be one of the most indomitable figures of his age, and though he was not a major New Jersey figure, he belongs on Billy Brigg's wall and every other one that claims to be Irish.

Robert Adrain is represented, and his story is New Brunswick made. Adrain was born in Carrickfergus on September 30, 1775. His parents are unknown, but his father was a schoolteacher who also made mathematical instruments. In 1790, when both his parents died, Robert left school to support himself and four younger brothers and sisters. But by 1798, he had become successful enough to get married and become a revolutionary. In the uprising of '98, Adrain was shot in the back but survived and escaped with his wife to America. By 1809, Adrain was teaching at Rutgers and living in New Brunswick. After a strange career as a famous mathematician,

Adrain died in New Brunswick in 1843, aged sixty-eight, New Brunswick's most famous United Irishman.

At the bottom, just above the stool level, are two who should never be forgotten. William Maxwell was born in Ireland (the only proof is he said so, but no one argued it) but arrived in New Jersey as a child. He entered colonial service in 1758 and soon was commissioned an officer and member of the provincial congress from New Jersey. He served through almost every major engagement in New Jersey, becoming a field general, plus Sullivan's expeditions against the Indians in the Mohawk Valley. He was particularly resourceful in the Battles of Trenton, Monmouth and Elizabethtown. Washington said of him, "I believe him to be an honest man, a warm friend to his country, and firmly attached to its interests." Maxwell died in 1798, a New Jersey Irish hero.

The last is Francis Barber, born in Princeton of an Irish father from Longford and destined for greatness before a cruel accident deprived the United States of a magnificent future. Barber was born not ten miles from Tir Na Og pub in 1751, the son of Irishman Patrick Barber. He graduated from Princeton and became a teacher in Elizabeth, where he met and married first one Ogden girl, Mary, and then, after she died of smallpox, her sister. He was renowned as a teacher, friend and soldier. He served as a major in the Third New Jersey artillery and fought in the Battles of Trenton, Princeton, Brandywine and Germantown and was severely wounded at the Battle of Monmouth. He continued his military career, fought in Virginia and was present at the surrender of Yorktown. At the close of the war, Washington sent Barber, in February 1783, on a mission to tell select people about the signing of the treaty in Paris. In West Windsor, New York, just over the northern border of New Jersey, a tree felled across the road by fellow U.S. soldiers killed Francis Barber and his horse instantly. Francis Barber, one of the most courageous and popular figures of the Revolution and a first-generation Irish-American, was dead at thirty-two.

All this courtesy of the Camden-born and Bordentown-raised Billy Briggs, a man dedicated to "keeping it real," as he was wont to say. Billy, a unique New Jersey Irish-American, died at the young age of fifty-six of cancer in 2008, but the history he recaptured in his Trenton pub is a testament to the Irish presence in Trenton and beyond. If a thirsty traveler is looking for Notre Dame pennants, "Kiss Me I'm Irish" buttons or green beer, avoid Tir Na Og. Billy Briggs may be gone like so many of the patriots whose stories and pictures adorn the walls of Tir Na Og, but the pub is still real, and his Irish legacy, like the canals, remains for all of us to enjoy.

"It's a Long, Long, Way From Clare to Here": John P. Holland

Of all the subjects in this project, John Holland may be the most recognizable to the general reader of both New Jersey and Irish-American history. Holland and the submarine are synonymous, but many readers will be surprised at the long struggle leading up to his invention and the obscurity that followed his success. The story of Holland, from his quiet beginnings in County Clare to his even more silent death in Newark, needs to be retold. Less than forty days after Holland died, a German submarine began a new phase of modern warfare by blowing up a British ship, and Holland's legacy was cemented in history. Cemented but generally ignored.

John Philip Holland Jr. was born in Liscannor, County Clare, in February 1841, four short years before the famine devastated the west of Ireland. Holland's father, John Sr., was a member of the Irish Coast Guard who patrolled the Clare coastline on horseback (somewhere there is an Irish joke here). Holland Sr. died some short years later, an apparent but unproven victim—like a million others—of the Great Hunger. John Jr. often claimed that his days spent with his dad began his love of the sea. Following her husband's death—and loss of family income—Mary (Scanlon) Holland moved her family of three boys (another son, Robert, also died during the famine) to Limerick, where John eventually came under the influence of some leading Irish Christian Brothers. Turned down after applying for the Merchant Marine because of poor eyesight, John became an Irish Christian Brother and taught in Ireland until 1873.

Resigning from the order, Holland followed his family to America and within months found himself teaching in a Catholic school in Paterson. Between 1874 and his death in 1914, John P. Holland toiled away at his two single-minded dreams—proving that the submarine could revolutionize the modern world and that it could and should be used to free Ireland from British rule. Holland's life ended at age seventy-three; he never knew that he would forever be known as the "Father of the Submarine" and that his dream for Ireland would still be a dream deferred.

For more than forty years, Holland lived and worked in his adopted state of New Jersey and became a naturalized citizen in 1882. His primary job throughout his adult life was as a schoolteacher at St. John's School in Paterson. Much like another famous Limerick schoolteacher, Brian Merriman, who wrote the classic Irish poem, "The Midnight Court," Holland toiled at

John Holland's boyhood home in Liscannor, County Clare. Holland lived in the Garden State more than forty years, dying in obscurity. *Author collection.*

his day job and worked the dream at night. As John worked single-mindedly on his early prototypes of the submarine, his youngest brother, Michael, introduced him to members of the Irish Fenian Brotherhood. The meetings were auspicious, as leading Fenians saw the possible uses for the schoolteacher's dream. For the next few years, Fenian money was able to bankroll Holland in his work on the submarine.

With this backing, John was able, in 1883, to produce a sixteen-foot model known as the "Fenian Ram." With this brief success, and believing in the inevitability of his invention, Holland gave up his teaching at age forty-two to work full time on submarines. He continued for four years before falling in love with and marrying Margaret Foley. This late marriage produced six children, four of whom would live to adulthood. But marriage and children notwithstanding, John Holland was relentless in his efforts to convince others of his dream. He succeeded with many, enabling him to produce better and better prototypes. There was only one entity that Holland could not ultimately win over—the bureaucracy of the United States Navy. Though John won grant after grant, he could never win the favor of the high brass. It would be his biggest failure, and some thought he was an Irish Quixote tilting at windmills or propellers.

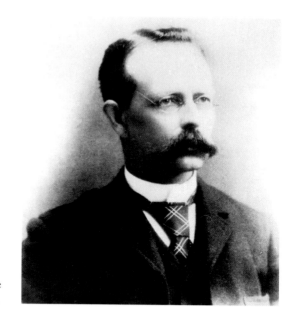

The quiet professorial young teacher from Paterson taught at St. John's School for years while developing submarines in his spare time. *Paterson Museum Collection.*

The *Holland VI*, his last and best effort, was launched from Elizabethport in 1897, and following minor improvements, he forwarded his plans to the navy in early 1899, when he was fifty-eight years old. The navy finally agreed to build six more like the *Holland VI* in late 1900, but under the supervision of navy constructor Lawrence Spear—a man Holland believed was absolutely unqualified for the job. After two years of battling Spear and an indifferent bureaucracy, the proud and gifted Holland was worn out and gave up the fight. He was sixty-three, frail and heartbroken.

Holland withdrew from public life and moved to Newark with his family. He died almost unnoticed of pneumonia on August 12, 1914, at age seventy-three after suffering for several of these last years with rheumatism. Forty days later, a German submarine based on Holland's work and manned by twenty-six men torpedoed three British cruisers off the Dutch coast. Fourteen hundred men died. From that moment, the Holland legacy began in earnest. The only public recognition Holland ever received during his lifetime, however, was the Medal of the Rising Sun, from Japan, when that country defeated the Russian fleet with the help of Holland's submarine in 1904–5. There is only one small mark of John Holland at the United States Naval Academy, and only the Paterson Museum has recognized his brilliance.

Many New Jersey citizens with some inkling of history mistakenly believe that the Holland Tunnel is named after the great single-minded schoolteacher,

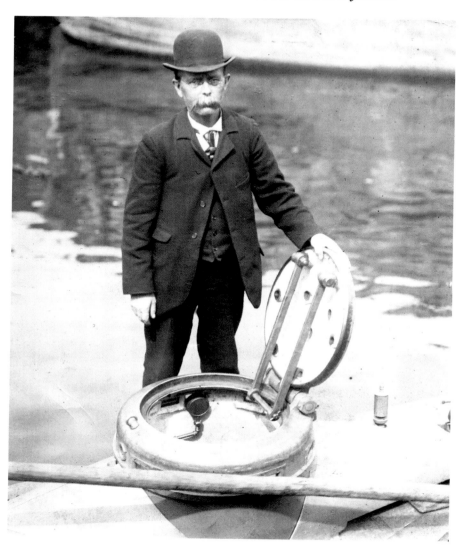

The shy Holland in his usual subdued pose atop his sub in Perth Amboy, 1895. *Paterson Museum Collection.*

but even that is incorrect; the tunnel was named after its first engineer, Clifford Holland. John Holland is buried in Holy Sepulchre Cemetery in Totowa. In 1964, a plaque was erected in Liscannor to mark the fiftieth anniversary of their native son, and his boyhood home has been restored. He was a quiet genius, who like Alfred Nobel has left a great and indelible legacy. He was Irish, and a Jersey guy, too.

"Architects to the Sky": Keely and O'Rourke

Until *An Gorta Mor*, the "Great Hunger," struck Ireland in the middle of the nineteenth century, Catholicism in the United States was uncounted, unwanted and, where present, hidden in the shadows. In the middle of the famine, the very worst year, forever after known as "Black '47," there may have been as few as fifty Catholic churches on the entire eastern seaboard, and they were generally built of wood or simple stone. The utter explosion of Catholic humanity to America from Ireland and Germany in the next fifty years demanded churches, schools and cemeteries. Into this void stepped two Irishmen who literally changed the landscape of Catholicism in the United States.

There was at first a lack of money, considering the initial huge wave of Irish immigrants arrived with nothing in their pockets but dust. Money would be found, penny by precious penny. Even land to build on was difficult to find if locals found it was to be used for a Catholic church, but money talked then, just as it does today. Perhaps the biggest obstacle was the dearth of professionals capable and interested enough to construct a church for Catholics, a religion most American wasp architects didn't want in their own backyards in the first place.

All that changed when Father Sylvester Malone ran into a Brooklyn carpenter recently arrived from Kilkenny. The two men were made for each other. Malone was a young pastor with dreams for a new church in his Williamsburg parish. Patrick Keely was equally as young, with energy and skill to match Malone's dreams.

Patrick Charles Keely was born on the job in Thurles, County Tipperary, on August 9, 1816. His father was himself an architect who built Saint Patrick's College in Thurles, as well as the local hospital. Raised in such a household, it should come as no surprise that upon immigrating to Brooklyn at age twenty-five, Pat would be anxious for a similar career in America. For a few years, the idea lay dormant, until Malone raised the concept of a new church. Keely sprang into action with an idea based on Gothic architecture—a church with pointed arches, pinnacles and buttresses. It was rejected a few times as either too ambitious or too expensive, but eventually Malone and Keely were given the go-ahead. When St. Peter and Paul's was dedicated, a new era had begun. Keely was inundated with requests from clergy throughout the East and New England to help build churches for their burgeoning flocks.

He did not disappoint. In the next fifty years, the Keely architectural firm was responsible for more than six hundred churches, mostly but not all

Begun in 1897, Sacred Heart Cathedral is the fifth largest in the country. Pope John Paul celebrated Mass there in 2005. *Newark Public Library*.

Catholic, throughout the United States. Pat Keely married New York–born Sarah Farmer, and his brother in-law, James, and Keely's own children made the Keely name famous.

In New Jersey, Keely was especially busy. In Jersey City, St. Bridget's, St. Patrick's and St. Michael's, as well as Saint Peter's Church and College were

all Keely-made. In New Brunswick, Pat and his family built St. Peter's and the Church of the Sacred Heart. In Paterson, they did St. John, and in Mt. Holly, the Church of the Sacred Heart. In Newark, St. Patrick's Cathedral, and in South Amboy, St. Mary's, were made with the Keely imprint. Another dozen can be found easily. Amazingly, most of Keely's work in New Jersey is not only still standing but also operating as viable places of worship. Some are historical landmarks.

Pat Keely continued building churches, even when two of his sons, John and Charles, died young and suddenly. Pat himself lived until 1896, after building more than three hundred churches from New Jersey to Wisconsin, including twenty cathedrals. Recognition came from all over the Catholic world for both Pat and his work, but it never came from his fellow architectural professionals. Was it anti-Irish bigotry or jealousy of his huge practice? Probably both. After all, when the first Keely church was built in 1847, the Know-Nothings were at their height of hatred, and despite gains made by the Irish in the second half of the nineteenth century, the Irish were not everybody's cup of tea, especially upper-class architects. The Keely name is mentioned only twice in the professional journal of the time, the *American Architect*—once when young son Charles died in 1889 and then again when Pat himself passed on in 1896.

Has he been forgotten? In the research done thus far, only one historian, Dr. Kevin Decker of SUNY Plattsburgh, has spelled Keely's name correctly. All other references spell it Kealy, this despite the fact Keely and all members of his family never spelled it any other way than Keely.

Pat Keely built many churches in New Jersey, but his chief competitor and fellow Irishman, Jeremiah O'Rourke, built even more. O'Rourke arrived a decade into the fray, but he made up for lost time. He was born in Dublin in 1833 and graduated from the Government School of Design in 1850. Just a few months after graduating at age seventeen, O'Rourke landed in Newark with both feet running. He quickly became the chief rival in church design to Keely, and it was a rivalry both enjoyed. As the first architect in Newark history, Jeremiah built more than four hundred churches and succeeded in one area Keely did not. The O'Rourke firm was able to branch out, and at one time Jeremiah was named by President Cleveland as the U.S. supervising architect in Washington. This led to many federal buildings being built by the O'Rourke firm.

Like Keely, Jeremiah raised a large family and stayed in his American homeplace of Newark. Also like Keely, O'Rourke soon had several of his children working in the business. Among other churches in New Jersey, the O'Rourkes built St. Mary's in Wharton, the Cathedral of the Sacred Heart

and St. Joseph's in Newark, the Church of the Immaculate Conception in Camden, St. John's in Orange, St. Mary's in Rahway and the main building of Seton Hall University.

O'Rourke's three sons, Joe, Louis and Charles, were all active in the business, and all three sons stayed in New Jersey. Jeremiah O'Rourke outlasted Keely by two decades, dying in 1915 at age eighty-two. Together these two Irishmen built almost one thousand churches in the United States, many in New Jersey. O'Rourke and Keely—it is hard to worship in, drive by or live near a church in the Garden State that doesn't have their imprints. They have left a great legacy we should remember.

Heroes Come in Different Forms

"The Spy From Armagh": John Honeyman

John Honeyman is one of the great stories not only of the Revolution but also of all American history. Paul Revere had his ride, inaccurate as it might have been; Benedict Arnold sold his country down the river; and Aaron Burr made a mess of a brilliant life—but all three are well known in American history. They would possibly all be surpassed in the history books if one letter had not been lost in New Jersey.

John Honeyman is presently a footnote, known only to aficionados of colonial history and website followers. Honeyman had no publicist like Revere, didn't become a traitor like Arnold and did not live the high life in Philadelphia and New York City like Burr. John Honeyman did his hero's work for eight long years as George Washington's spy and then retreated to his small farm in New Jersey, where he raised a large family and kept his story to himself like the colonial Cincinnatus he was. But American history might not be the same without this quiet Irishman from central New Jersey, though Honeyman is not listed in almost any Irish-American histories and is not given an entry in the wonderful *New Jersey Encyclopedia*.

The Honeyman story has been passed down orally for well over two hundred years, and it was first put in writing in 1873. Not once has it been disproved, "as far as can be determined." John was born in Armagh in 1729 of farmer stock, and though his early life in Ireland is blank, sometime

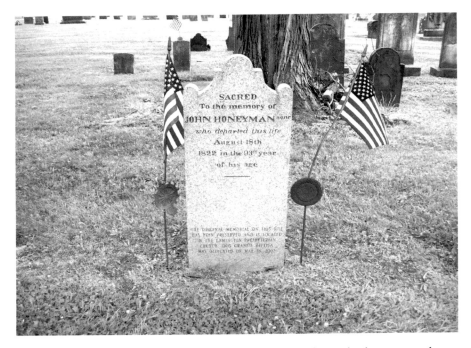

The gravestone of John Honeyman in Lamington. The original stone has been removed indoors for protection, leaving this new replacement. *Author collection.*

around 1758 he either joined the British army or was impressed into its naval service.

Onboard a ship in the Atlantic, Honeyman saved General James Wolfe from a bad fall and from a possible serious injury. Wolfe was impressed by the act and eventually added John to his personal guard detail. Soon after, the British, led by Wolfe, fought the French at Quebec, and on the Plains of Abraham General Wolfe was killed. According to family legend, he died in Honeyman's arms. Interestingly, there is a famous painting of the general's death, with several soldiers surrounding him, including one holding Wolfe in his arms.

Following the French victory and the end of the Seven Years' War in 1763, Honeyman landed in Philadelphia, where he met and married Mary Henry, a fellow Irish immigrant from Coleraine. Among his few possessions were his discharge papers from the British service and a letter from General Wolfe requesting him to be on his bodyguard staff. Family and friends saw these papers long after the Revolutionary War.

Honeyman and Washington met in Philadelphia, either just before or right after war was declared, and then again in Hackensack, with letters shown

and loyalties exchanged. Honeyman agreed to act as Washington's agent and moved his family to Griggstown, New Jersey, in 1776. There he stayed—or should we say, his family stayed—for the remainder of the war. But certainly not without incident or consequence.

The short version of the Battle of Trenton and John Honeyman's place in it is as follows. Honeyman arrived in Trenton as the "known Tory" and observed the scant preparation of the British. He allowed himself to be captured by Washington's men and detailed in a private meeting what he had seen. Soon after, Honeyman escaped from the American camp, with Washington's help, and returned to Trenton. He told the Hessians he had been in the American camp and that they were morally bankrupt in the fight and done for the winter. The rest of course is known. The Battle of Trenton is one of the two or three turning points of the entire Revolution, and some agree it was the most important (and first) victory.

When word of John's arrest and escape from Washington's camp reached Griggstown, residents reacted immediately. Convinced and incensed that John was acting as a British spy, residents turned out to burn down his house and evict his family. Just before they did, Mary Honeyman let the soldier in charge of the mob read a letter she produced. Signed by George Washington, it allowed the Honeyman family—but not John himself—freedom and protection. The letter, seen by an American officer, was dated "American Camp, New Jersey, Nov. A.D. 1776." The soldier believed it to be authentic and persuaded the crowd to disperse. Mary and her Honeyman children lived out the war in the same house and were never bothered again. According to that soldier and Honeyman relatives, the letter read:

> *To the good people of New Jersey and all others whom it may concern: It is hereby ordered that the wife and children of John Honeyman of Griggstown, the notorious Tory...shall be and are hereby protected from every quarter until further orders. But this furnishes no protection to Honeyman himself.*

Soon afterward, John Honeyman was in serious trouble. He was arrested and indicted by the New Jersey colonial government for high treason, punishable by death, and locked in, of all places, the Trenton jail. Fifteen days later, he was released on bail, an unusual step for a charge so grave. Even stranger, the man who stood the bond was Colonel Joseph Hyer of the New Jersey Militia. When Honeyman came up for trial, he was very quietly released.

In 1779, an ad announced that Honeyman's Griggstown possessions would be sold on April 9, a common tactic against Tories. The sale never took place. Following the war, Honeyman alone of all suspected or known Tories was not prosecuted or persecuted. Most were sent to Nova Scotia and their property confiscated. Being a Tory in New Jersey at the end of the war was not healthy, since so much fighting took place in the state and atrocities were long remembered. Honeyman's daughter, Jane, also remembered a group of Continental officers in full uniform riding up to their home at war's end, followed by some curious residents. The officers turned into Honeyman's yard, and George Washington stepped onto the porch and thanked John Honeyman for his service to the country. The house in Griggstown is still standing, with a small plaque identifying it as the house of the Patriot John Honeyman. Soon after, John, Mary and their children move to a much larger, four-hundred-acre farm on much better land in Lamington in nearby Somerset County. Where did this cattle-driving Tory get the money—right after the war?

Mary died in 1802, after raising seven children. Honeyman, for reasons unknown, remarried in 1804 at age seventy-three to a widow with two children. John died two decades later, in 1822, at age ninety-one and is buried in Lamington Cemetery. His gravestone is still visible. Six of his seven children married and had very large families, and there are Honeymans all over both New Jersey and the rest of the country.

There is just one monument in the entire country to this Irish-American. It is a fountain dedicated by the Patriotic Sons of America in 1930 at Washington's Crossing on the New Jersey side of the Delaware. It reads:

> *Dedicated to the memory of*
> *John Honeyman*
> *Who served George Washington*
> *And the Continental Army*
> *As a Spy.*
> *Drink of the Fount of Liberty*
> *Let Posterity Inherit Freedom.*

The letter from Washington that would have sealed John Honeyman's place in history went missing sometime after 1800, and though seen by dozens of people prior, its contents no longer pass muster with very stringent historians. It has been said that all John's children disliked Honeyman's second wife, and she wanted no part of hearing about John's service (and probably Mary's heroics). The personal effects of Honeyman are said to have gone missing

about this time. Is it possible that a vindictive second wife might react in such a manner? Does an apple tree make apples?

David Hackett, who wrote a prize-winning study of the Battle of Trenton, mentions John Honeyman once in 517 pages, and then only in a footnote to dismiss the story. Seriously conservative historians may decry his story publicly (though not privately), but general readers are free to take a tiny leap of faith now and then. Honeyman is worth it, but believe what you will. Most Irish groups, perhaps because of his so-called Scotch-Irish name, have also ignored Honeyman. The man, however, was an Irishman, born in Ireland; he considered himself an Irishman and lived a hero's life as a Jersey citizen. He should be remembered as both.

"The Hilltopper": Chuck Feeney

You can only wear one pair of shoes at a time.
—Chuck Feeney

In Elizabethtown, like almost everywhere else in New Jersey, they were kept out for two hundred years. There were no signs entering or leaving town, but everybody knew: No Catholics. In 1829, three of these confirmed idolaters were found to be residing within town limits and were "obliged to leave, as no employment would be given them." But then it came down to the big decision—money or Catholics? Like so many other cities in the Northeast, they chose the money, and Catholics, in the form of the Irish, were allowed residence to build the railroad, the mills and then the factories. It was a fateful—some might argue inevitable—decision, but these early nineteenth-century Irish weren't the only ones, just the first. Soon, Germans followed, then more Irish and before you knew it, the Italians, Poles, Ukrainians, Lithuanians, Russians, Jews and, in the last half century, African Americans, Cubans, Portuguese, Koreans and Haitians. Today, the only people not living in diverse Elizabeth are the people who lived there for the first two hundred years. The only Ogdens, Prices, Woodruffs and Boudinots left in Elizabeth are on street signs.

Follow the canals and rails from New York to Philadelphia in the nineteenth century, and you will follow the Irish in New Jersey. In group settlements, the Irish were found in any town along the routes of the two great New Jersey

Only a legal loophole enabled the anonymous gifts of this wonderful man to become public, though he still remains relatively unknown and completely unaffected. *Ireland First Library.*

canals. Jersey City, Newark and Paterson in the north were first; Trenton, New Brunswick and Perth Amboy in the central part of the state soon followed. Elizabeth and Camden had to wait for the railroad, so it wasn't until after 1840 that Irish neighborhoods popped up throughout both towns. Elizabeth, in 1844, was home to about five thousand people, and twenty-five were Catholic. As the population grew, three questions became paramount to these and future immigrants: where do we worship, educate our children and bury our dead?

In Elizabeth, the first Catholic church was Saint Mary's. For a decade, the Irish traveled on Sundays, often on foot, to Newark. Sometimes a priest would be rowed over from Staten Island for services, where he was forced to say Mass in a tavern outside town. In 1844, Father Isaac Howell was appointed the first pastor in Elizabeth, and within two years the people had a church. By 1851, there was a St. Mary's school, and a cemetery soon followed. Today, St. Mary's Grammar and High School still sits on the top of a small knoll on South Broad Street, overlooking downtown Elizabeth and the same railroad its Irish papists built 150 years ago. Since its inception, all St. Mary graduates have been known as "Hilltoppers." In the long history of this predominantly Irish school, there have been many favorite sons and daughters, but none is more appreciated, or anonymous, than Charles "Chuck" Feeney, St. Mary's class of 1948.

Chuck Feeney was the backseat guy growing up. Not a great athlete or an honor student, and like most Hilltoppers not financially well endowed, he was just a regular Irish kid whose mother was a nurse and whose father was an

insurance underwriter. A working-class family, but hell, just about everybody in Elizabeth could be described that way, even today. Chuck Feeney looked forward more to the basketball game against rivals Jefferson High (now Elizabeth High School) and downtown St. Patrick's than he worried about SATs, college or the future.

In the summer of '48, and facing military call up, Chuck Feeney took the easy way out and "jumped the line" at seventeen, volunteering for service in Japan and Korea. He returned, and like thousands of other young soldiers, used the GI Bill to get the education he either didn't want or wasn't ready for at seventeen. Feeney ended up at Cornell, where he barely got by financially, but he graduated in 1956. With what little scholarship money he had remaining, Chuck applied for a political science course and ended up in Grenoble, France, where he hooked up with fellow Cornell student Robert Miller.

Miller and Feeney began selling perfume, tape recorders and transistors to the fleet, and by 1960 they opened up DFS (Duty Free Shoppers). They got lucky. As Feeney admits, "We caught a wave," and by 1980, DFS had become a global retail empire. In 1988, Chuck Feeney was worth, according to *Forbes* magazine, $1.3 billion and was among the world's richest men. But the Elizabeth Hilltopper didn't belong there. Six years earlier, in 1982, he had secretly and irrevocably transferred his entire 39 percent interest in DFS to a number of foundations. Even his partner, Bob Miller, had no idea.

Why? Could it be as simple as he said: "I did not want money to consume my life." Yes, and in many ways, it appears Chuck Feeney is exactly the same E-Town guy everybody knew at St. Mary's. But what was even more remarkable than the intention of giving away his money was the anonymous way he did it. Feeney became a firm advocate of the Seamus Heaney line, "Whatever you say, say nothing."

From about 1981, when he gave Cornell $700,000, until 1997, when it is estimated he had given away more than $700 million total, all was given anonymously. To maintain secrecy, he declined to take personal tax deductions and often gave money away in cashier's checks or cash. Often, recipients had no idea where the money came from. "I just didn't see the need for blowing a horn," he said in 2003. He took care of his French-born wife and five children, and as he says, "They all grew up quite normally and have acquitted themselves honorably. Today they have all they need in life."

Though always involved in his Irish ancestry and doing business in Ireland since the 1970s with DFS, Chuck Feeney has stepped up his involvement, giving to universities, special projects and, in the last decade, the Peace Process, as it has become known. Feeney's special love is libraries, his own and others'.

"I love to go to a library and see kids sitting there," he says. "It's nice to see the lights burning late and students studying."

Charles Feeney is not and never has been reclusive. He travels and, though he has no home or car, is not hiding from anybody or anything. "Home is where the heart is, and where my books are," he said to the *New York Times* in a 2003 interview. Why and how did Feeney become a known commodity after years of walking the streets of Elizabeth and the world looking like the schoolteacher he resembles? It was not part of his plan, but in 1997, the breakup of DFS with Miller was not gentle, and the legal wrangling exposed it to the world. Though he still does not go out of his way to be seen, Feeney has done a few interviews—a few—so people do not think he is a modern Howard Hughes, or even worse, an Irish Donald Trump begging to be seen and heard every five seconds. "I am not an event person," he explains. "There is too much focus on people." Feeney has refused honorary degrees, and his name does not appear on any building in the United States.

In 1998, Chuck Feeney organized a reunion in Limerick for the class of 1948, St. Mary's High. He made sure everyone could go. Charles Feeney—a Jersey guy, an Irish-American from Elizabeth for sure, but a Hilltopper most of all.

"Men of Mettle": Seven Irish Representatives

This is our home now. Thousands and thousands of Irish immigrants have come here...you will stand by the country.
—*General Thomas F. Meagher, 1861, resident of Jersey City*

Sometimes it is courage that makes history. President Abraham Lincoln recognized this, as he did so many other things, and on March 25, 1862, Lincoln awarded the first Medals of Honor in United States history. Since that date, more than thirty-four hundred others have been awarded the Medal of Honor. It has, these last 150 years, become the highest honor any American might receive. Both Presidents Harry Truman and Lyndon Johnson said they would rather receive the Medal of Honor than be elected president.

Over time, the meaning of the award has been strengthened greatly. In the beginning, some medals were given erroneously, and early on individual soldiers could apply for the honor themselves. The process has been

ongoing, and the award may now be the world's most famous symbol of courage. No politician can receive it; nor can any civilian. Only a soldier in the armed forces of the United States is eligible, and surprisingly, no one can receive the award for having acted under orders, no matter how heroically those orders are carried out. The Medal of Honor is reserved strictly for those who act of their own accord and out of complete selflessness. It is the only award in the United States where the president salutes the recipient, who then returns the salute.

The Medal of Honor has been further strengthened, especially since World War II, by the difficulty of survival. Since that time, more awards have been made to the dead than the living. Allen Milaelian, author of *Medal of Honor* in 2002, says that only 147 Medal of Honor winners are still alive. Most people recognize that recipients have utter disregard for the safety of their own lives and act only to save others.

Almost 500 foreign-born soldiers from thirty-three countries have won the Medal of Honor. It comes as little surprise that more than half—258—have come from Ireland. The next highest is Germany, with 128. Needless to say, New Jersey is well represented among these ultimate patriots, a goodly number being Irish-Americans. Seven have been chosen here for their diversity, their courage and their ordinariness, one as an example of a medal and life gone wrong, and some history will be corrected. Like so many other people chosen in this work, it is their very ordinariness that makes them so extraordinary. We must be witness to their sacrifice or we will suffer from the same unanswered question of the Holocaust poet Paul Celan, who asks, "What happens if there are no witnesses to the witnesses?"

An early recipient of the cherished medal was Thomas Timothy Fallon, born in County Galway on August 17, 1837. When civil war broke out, Tom Fallon was already living and working in Jersey City as a single man. He enlisted, like so many Jersey boys, in a New York regiment, the Thirty-seventh Infantry, which was often called the "Irish Rifles." Fallon began his fighting career in the Peninsula Campaign of coastal Virginia. Tom was awarded the Medal of Honor for his combined bravery at the Battle of Williamsburg on May 5, 1862, and at the Battle of Fair Oaks on May 30 and 31, 1862, as well as for his bravery at the Big Shanty, in Georgia, on June 14 and 15, 1864. Unlike most soldiers of that war, Fallon fought a full five years. He would be both lucky and determined. His Medal of Honor citation reads:

At Williamsburg, Va., he assisted in driving rebel skirmishers to their main line. He participated in heavy action at Fair Oaks,

though excused because of disability. In a charge with his company
at the Big Shanty, he was the first man on the enemy's works.

Ironically, Fallon served in his first battles under Phil Kearny, another Jersey guy discussed in another chapter.

Williamsburg, a rarely discussed battle, was as awesome a firefight as was ever witnessed in the war, and some veterans of four full years in the war, on both sides, later would say that the swamp conditions at Fair Oaks had a volume of fire unmatched in their wartime experience. At Williamsburg, the Union forces walked into an ambush in torrential rain and were decimated by Confederate firepower before regrouping and taking the town of Williamsburg. Now an area of colonial history and a theme park, a visitor would be hard-pressed to even know that it was once a Civil War battlefield, but men like Fallon never forgot it.

Following the war, Fallon married a Jersey girl and moved to Freehold, where he raised a family with two daughters. He died in Freehold in 1916, at the age of seventy-nine. He is buried in the state he made his home, at St. Rose of Lima Cemetery in Freehold.

Tom Sullivan was born in County Meath on April 20, 1859, less than a decade after the famine. It is unknown when he immigrated to the United States, but he was living in Newark when he entered the service of the United States Army. Sent west, Tom served as a private in Company E in the famous Seventh Cavalry. He was awarded the Medal of Honor for his bravery at Wounded Knee, South Dakota, on December 29, 1890. His citation reads, "Conspicuous bravery in action against Indians concealed in a ravine." His medal was awarded on December 17, 1891. There has, of course, been a major controversy over the awarding of some of the medals at Wounded Knee, but Tom's version has never been questioned, and until it is, his name will remain untarnished and his medal and memory deserved.

Following his stint in the Indian Wars, Sullivan returned to New Jersey and became a policeman in Newark, where he lived the rest of his life. He died on January 10, 1940, at the age of eighty. Newark's most famous Indian fighter, Sullivan is buried at Holy Sepulcher Cemetery in East Orange with his wife, Ellen, who died in 1934 at age sixty-four.

Francis Xavier Burke had a different story. Burke was born in New York City on December 29, 1918, at the height of the worst influenza epidemic to hit the world in five hundred years. When he was a baby, his family moved to Jersey City, where he attended school before joining the army during World War II as a lieutenant in the Third Infantry Division.

Francis Xavier Burke receiving the Medal of Honor from President Harry Truman for his actions in World War II. New Jersey Veterans Journal.

Frank Burke was awarded the Medal of Honor for extreme gallantry in the streets of war-torn Nuremberg, Germany, where his battalion was engaged in rooting out fanatical defenders of the citadel of Nazism. Detecting a group of about ten Germans making preparations for a counterattack, this battalion transportation officer rushed back to a nearby American company, secured a light machinegun and daringly opened fire on this superior force, which deployed and returned his fire with machine pistols, rifles and rocket launchers. In four hours of heroic action, First Lieutenant Burke single-handedly killed eleven and wounded three enemy soldiers and took a leading role in engagements in which an additional twenty-nine of the enemy were killed or wounded. His extraordinary bravery and superb fighting skills were an inspiration to his comrades, and his voluntary mission into extremely dangerous territory hastened the fall of Nuremberg. Frank Burke lived until 1988, when he died in Jersey City

on September 6, aged sixty-nine. He is buried in the Veterans Memorial Cemetery in Jersey City.

William McGee, unlike our other heroes, was a fraud. Born in Newark in 1847, McGee was a fourteen-year-old waiter from a dysfunctional husbandless Irish immigrant family and enlisted for the bounty money in Newark on July 28, 1863, as a drummer. At age seventeen he was awarded the Medal of Honor for his actions during the Battle of Murfreesboro, on December 18, 1864, though future research would reveal that his medal was undeserved and that he was not even present at the firefight.

Willie McGee became a New Jersey hero, though like so many child actors pushed into the limelight before they are ready, he came to a bad end. After mustering out at Washington, D.C., on July 17, 1865, McGee was pushed by Governor Marcus Ward into the army as an officer simply because he had received the Medal of Honor. This New Jersey poster child, a commissioned second lieutenant, shot and killed an unarmed regiment doctor in Baton Rouge, Louisiana. McGee was sent to prison for five years and stripped of his commission, but he received a presidential pardon within two years because of New Jersey political pressure.

McGee never straightened out; alcohol and drugs took hold and never let go. He was married three times, twice illegally, and murdered a second man in New York when he was fifty, ending his life as a prisoner at Sing Sing. He pawned his Medal of Honor at least twice and outrageously claimed to have fought with Custer, one of several men to perpetuate that fraud in the nineteenth century. Unfortunately, McGee is still listed in the Medal of Honor roll books, an action besmirching the honor of hundreds of other heroes.

Tom McGuire was born in Ridgewood in Bergen County in 1920 but moved to Florida at age ten to live with his mother after her divorce. At twenty-one, McGuire began serving in the Pacific in the Army Air Corps, and by 1945, this magnificent pilot was credited with downing thirty-eight Japanese aircraft, the second highest total in United States military history. Major McGuire was killed at age twenty-five when his plane crashed in the Philippines covering a fellow fighter pilot, and soon after McGuire Air Force Base in Lakehurst was named in his honor. Unlike most recipients, McGuire personally sought the Medal of Honor desperately, and his is wish was granted, though posthumously, in 1946.

Frank W. Crilley was born in Trenton on September 13, 1883, and enlisted in the navy at age seventeen. He became a gunner's mate and a deep-sea diver. In 1915, while a chief gunner's mate, he made dives of over 300 feet during salvage operations on a sunken submarine near Honolulu, Hawaii. On April 17, he

rescued a fellow diver who had become entangled at a depth of 250 feet. For his heroism on this occasion, he was awarded the Medal of Honor in 1929. His navy career continued, and he was awarded the Navy Cross in 1928. In 1967, the USS *Crilley* was named in his honor. He died at the Brooklyn Navy Yard on November 23, 1947, after a lifetime in the United States Navy. He was sixty-four and is buried in Arlington National Cemetery.

Perhaps the most accomplished Irish Medal of Honor recipient in New Jersey history, however, was William Joyce Sewell, the orphan from Mayo. Sewell was born on December 6, 1835, in Castlebar, during

Top: Tom McGuire deserved the Medal of Honor, but he never lived to see it, dying at age twenty-five in the Philippines. *U.S. Air Force Collection.*

Bottom: When Sewell's parents died during the famine, the young orphan immigrated to the United States, becoming one of New Jersey's greatest citizens. *Anna McHugh Collection.*

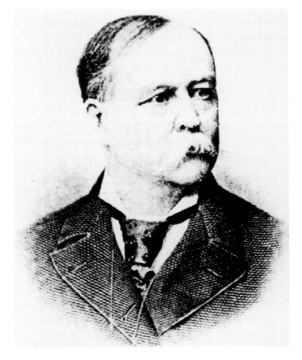

one of the worst winters in Irish memory, and it would only get worse. By 1850, at the tail end of the famine, both of Sewell's parents would be dead, two of the million plus who would die on the island between 1845 and 1850. The sixteen-year-old worked first in a shipping office in New York and then turned to the sea, working on a clipper, before turning up in Chicago. In 1860, one year before the outbreak of war, Sewell moved to Camden, where he remained for the rest of his life. At age twenty-five, he was already a man tested by the world. Soon, like the rest of America, he would be tested by war as well.

In August 1861, Sewell, already a widower, enlisted in the Fifth New Jersey, where he was commissioned a captain. During the Peninsula Campaign of 1862, Sewell was promoted to lieutenant colonel and again to colonel after Second Manassas. Few others match Sewell's wartime record. On the morning of May 3, 1863, Sewell led his regiment at Chancellorsville against three heavy Confederate attacks, and he then led his brigade in several counterattacks. By day's end, Sewell's forces had captured eight colors and one thousand prisoners before finally retiring when ammunition gave out.

Joyce Sewell was wounded at Chancellorsville and again at Gettysburg and was finally invalided out of the army after Spotsylvania. After a brief respite home in Camden, Sewell returned as a colonel of the Thirty-eighth New Jersey infantry. He served until war's end with that New Jersey outfit as a brigadier general. In 1896, Sewell, for all his courageous leadership and bravery, was awarded the Congressional Medal of Honor.

Sewell returned home to Camden at war's end and never left. He remarried, this time to Helen Heyl. They had five children, all of whom survived him. But it was his public life following the war that made W.J. Sewell a double legend in New Jersey history. He immediately became a railroad man and was primarily associated with the Camden & Amboy Railroad, which merged through the years until it became part of the Pennsylvania railroad system. In less than thirty years as the superintendent, Sewell's New Jersey railroad went from thirty-seven miles of track to more than three hundred. Control of the rails was the real power in New Jersey politics, so it was no surprise that Sewell was soon extremely active in southern Jersey. From 1872 to 1881, Sewell was a state senator who not only controlled politics in southern New Jersey but also helped to promote railroad expansion. In 1881, Sewell was a United States senator and served for six years. He returned to the U.S. Senate in 1895, a position he held until his death in Camden on December 27, 1901, at age sixty-six. He is buried in Harleigh Cemetery, near Walt Whitman.

SELECTED SOURCES

Note: Essential sources for this work include newspapers, libraries, periodicals, interviews and census records throughout New Jersey, as well as web sources where relevant on each subject. Within each chapter, the following sources are cited and may be of interest to the reader seeking more thorough study.

INTRODUCTION

Much of the information regarding the Irish in America has been gleaned from a personal Irish history collection of several thousand accumulated over forty years. The information on the McManus collection is a result of letters to and from the author and Reverend Laurence Murphy in 1980, former president of Seton Hall. In addition, reporter Jim Lowney interviewed members of the Seton Hall staff in the 1970s, including Monsignor McNulty's secretary, Kate Dodd.

WILLIAM GLEASON

Nineteenth-century baseball has found a resurgence of interest in the last two decades. Some books consulted included *The Beer and Whiskey League*, by David Nemec in 1994; Bill James, *The New Bill James Baseball Abstract*, 2001 (which true baseball fans must possess); *Shoeless Joe and Ragtime Baseball*, by Harvey Frommer (1992); and *Biographical Dictionary of American Sports: Baseball*, 1987 and 1992. The website "The Baseball Biography Project (Dan Lindner)" was helpful in any search for the career of Bill Gleason, as was BaseballReference.com with work by Hugh Campbell. Most other work was personal research by the author in New Jersey newspapers and census records.

EDWARD PATRICK WALKER

The 1961 biography of Walker, *Mickey Walker, The Toy Bulldog & His Times*, remains the only one written. Joe Reichler, a sportswriter, covers Walker's career well, both in and out of the ring, but it obviously leaves out the last crucial twenty years of Mickey's life. Walker's onetime manager, Doc Kearns, featured Mickey in his autobiography, *The Million Dollar Gate*, published in 1966. Boxing books, however, are rare, and as a result, much information on Walker and his era is found in newspapers, magazines and websites. *Ring Magazine*, *Fight Stories* and the *National Police Gazette* were three featuring Walker's career in depth. Boxing historian Jerry Fitch is the one who broke the news on Charlie Gellman's saving of Walker, and his story has been repeated in many boxing magazines.

THE PENNSYLVANIA LINE MUTINY

The primary modern source is John A. Nagy's *Rebellion in the Ranks: Mutinies of the American Revolution* (2008), but the earlier Michael O'Brien work *A Hidden Phase of American History* (1920) is also very valuable. Further

evidence can be found in *The Irish in the American Revolution* (1908) by James Haltigan. Concerning conditions at Jockey Hollow, Eric Olsen at the Morristown Park is an invaluable asset.

JOHN O'NEILL

Ironically, no biographies have been written about this fascinating man, but several have been written about the spy who helped ruin him. Henri LeCaron's 1892 *Twenty-five Years in the Secret Service: The Recollections of a Spy* was the first, and in 2008, Canadian Peter Edwards wrote *Delusion: The True Story of Victorian Superspy Henri LeCaron*. Fenian history is swamped with great reads. Regarding O'Neill, two of the best are the 1910 John MacDonald book *Troublous Times in Canada: A History of the Fenian Raids* and Hereward Senior's 1991 *The Last Invasion of Canada: 1866–70*. John Savage's 1892 work also covers O'Neill in *Fenian Heroes and Martyrs*. The Mary Martin Langan Notre Dame thesis of 1937, "General John O'Neill, Soldier, Fenian, and Leader of the Irish Catholic Colonization of America," helps greatly. I have done a modern and complete study of O'Neill's life in "John O'Neill: Irish Rebel and Fenian Soldier," available on the web. Lester DeeGee covers ground in the *Tennessee Historical Quarterly* in the winter of 1997 with "Tennessee's Bold Fenian Men."

FENIANS

The study of the Fenians still occupies a huge segment of historians' interests worldwide. Regarding the four mentioned in this chapter, *The Manchester Martyr* (1970) by Paul Rose tells well the story of Mike O'Brien. *New York Irish History*, in separate articles, tells the stories of J.P. O'Donnell and Jerome J. Collins. In its 2000 edition (volume 14), L.A. O'Donnell writes lovingly about the labor leader O'Donnell, and Karen Daly does the same for Collins. Terry Golway briefly mentions Collins in his 1998 work, *John Devoy and America's Fight for Irish Freedom*. The story of the ill-fated *Jeannette* can best be found in the *Jeannette* Inquiry, conducted by Congress in 1884. Michael

Gallagher's brief life can be deciphered from his widow's Civil War pension files, as well as his *Irish American* newspaper obituary in January 1865. An unpublished manuscript by Fenian expert Michael Kane of Pennsylvania, *American Soldiers in Ireland, 1865–67* helped greatly, as did fellow Fenian researcher Mike Ruddy of Tennessee, whose unpublished manuscript, "America's Irish Nationalists" (and other related Fenian articles), can be found on the Web.

TIMOTHY MURPHY

There are four published books about Tim Murphy. The first is a fictionalized 1953 account titled *The Rifleman* by John Brick. The second is from the 1976 *Pennsylvania Game News* (volume 47), an article by Jim Bashline entitled simply "Tim Murphy: Rifleman." The third is John Barnes's 2004 biography, *The Rifleman of the Revolution: The Story of Tim Murphy*. The last is Michael J. O'Brien's *Timothy Murphy: Hero of the Revolution*. The Northumberland County Historical Society also published a fine article by Daniel Mowry in March 1937 entitled "Timothy Murphy."

MARK McGARRITY

McGarrity has been a well-kept secret among American writers, first because he wrote under an Irish pseudonym, Bartholomew Gill, and second because he was a shy man and never a self-promoter. In addition, his works were all centered on Ireland, and Americans were generally unaware of his work. Ironically, he was relatively unknown in Ireland for the opposite reason. Wallace Stroby and Mark DiOnno of the *Newark Star Ledger* were fellow newspapermen and fiction writers, and their interviews were helpful, as was a long-standing study of the Gill series and one or two meetings with the mystery man himself. Newspaper articles, reviews, online bios and blogs are frequent but will never fully explain the measure of the man.

WILLIAM MAHONY

The story of W.H. Mahony has been simply a personal quest of mine for over fifteen years. The files of the American-Irish Historical Society yielded some letters Mahony wrote to Mike O'Brien, and census and genealogical work in New Jersey, New York and Connecticut, as well as newspaper work in the Newark Public Library and the New Jersey Archives, were of assistance.

JAMES BARTON

There exists at present no biography of James Barton, which is a shame. The early career of Barton can be found in Bob Callahan's 1987 *Big Book of American Irish Culture*. The *American National Biography* gives a detailed account of his varied work, though the best article on Barton may be Frank Cullen's "James Barton," in the spring 2004 edition of the *Vaudeville News and Star*. More on Barton can be found in *Jazz Dance*, a 1968 book by Marshall and Jean Stearns. Also consulted was *Vaudeville: From the Honky Tonks to the Palace* (1953) by Joe Laurie.

JAMES CALDWELL AND NICHOLAS MURRAY

Theodore Thayer's *As We Were: The Story of Old Elizabethtown* (1964) tells well the Murray/DeHart conflict, and Murray's 1845 *Notes on Elizabethtown* gives his version of the Caldwell murder. Edwin Hatfield's *The History of Elizabeth, New Jersey* (1868) also conveys the death of Mrs. Caldwell in a proper light. Also sourced were *The Memoirs of Dr. Nicholas Murray* (1862), *Kirwan Unmasked* (1869) by John Hughes and the *Newark Advertiser*, "The Caldwell Controversy." The incriminating 1916 article was in the New Jersey Historical series (volume 1) written by Joseph Folsom.

THE HEALYS

There have been two full-length biographies of the Healys, and therein lies the problem. In 1954, the Reverend Albert Foley wrote *Beloved Outcast: The Story of a Great Man Who Has Become a Legend*. For forty years this stood as the only record of the Healy saga, until James M. O'Toole of Boston College produced the brilliant *Passing for White: Race, Religion, and the Healy Family* in 2002. Both are excellent, but the very nature of the Healy family story is two sided. Certainly, O'Toole's version is more helpful, but it could not have been written without the Catholic (white) version of Foley. Using both sources, I have uncovered Irish records that may explain the differences in the early story of Mike Healy, again thanks to Anna McHugh of County Galway. In addition, Ann Upton of Haverford College has been extremely helpful with the Burlington Quaker history, another story waiting to be told more completely.

A small cottage industry has now arisen on the Web, with race a major factor. If there is a future in the Healy saga, it needs to be told through the eyes of sailor Mike Healy Jr. and perhaps should include a fictionalized account of the one Healy with the most agonizing personality, Eugene, the only one who broke off from the entire family and disappeared in the mist of history.

REVEREND JAMES B. SHEERAN

There are no published biographies of Father Sheeran. The primary source is Sheeran's own scarce war journal, *Confederate Chaplain: A War Journal of Rev. James B. Sheeran*, published in 1960, edited by the Reverend Joseph Durkin. It provides a brief and somewhat accurate biographical account, focusing mainly on the war years. Sheeran's New Jersey life is found in "The Story of a Parish," an 1892 article written by his successor, Father Joseph Flynn, and a 1972 pamphlet, *Church of the Assumption*, published privately for parishioners. The Monroe, Michigan library was helpful with Sheeran's Michigan years prior to his ordination, and the indefatigable researcher Anna McHugh, of County Galway, provided Irish records, heretofore unknown, of Sheeran's family.

PHIL KEARNY

Some information on the early Kearnys can be found in *The Old Merchant's of New York City* (1862) by William Barrett. The Kearny Public Library holds the Kearny Museum on the second floor and is a wonderful place to visit, learn and research. Of all the forgotten men in this volume, there is more information on Kearny than almost any other. William Gordon writes favorably in the 2004 *New Jersey Encyclopedia*, and a biography by Irving Werstein was produced in 1962—*Kearny, The Magnificent: The Story of General Philip Kearny*. In 1937, kinsman Thomas Kearny published *General Philip Kearny: Battle Soldier of Five Wars*. Often, Kearnys are omitted from Irish histories for reasons that are still unknowable. All serious works on battle leaders of the Civil War cover Kearny as well.

HUGH JUDSON KILPATRICK

There has been only one full-length biography of Kilpatrick—Samuel Martin's *Kill-Cavalry: Sherman's Merchant of Terror, The Life of Union General Hugh Judson Kilpatrick* (2000)—but numerous articles abound. A thesis from Penn State University in 1983, "Gen. Hugh Judson Kilpatrick in the American Civil War" by John Edward Pierce, and a 1998 *Civil War Times* article by Edward Longacre, "Judson Kilpatrick," are two of the best. Wayne King also helped with a *New Jersey History* article, "The Civil War Career of Gen. H. Judson Kilpatrick," another primary source. For those looking for deeper background, there is Kilpatrick's 1874 lecture, "The Irish Soldier in the War of the Rebellion," and the widow Louisa V. Kilpatrick's pension request history with the Department of the Interior. Both make interesting reading. Many Civil War works also touch on individual aspects of Kilpatrick's war career. Sussex County historian Wayne McCabe, of Newton, New Jersey, has a treasure-trove of Kilpatrick material.

FINN'S POINT

Like most subjects involving the Civil War, there is no shortage of research. One book focused totally on Camp Delaware is Dale Fetzer and Bruce Mowday's *Fort Delaware's Prison Community in the Civil War*. The view of these authors would, however, not be in agreement with those buried at Finn's Point. Lonnie Speer's *Portals to Hell: Military Prisons in the Civil War* (1977) is excellent, as is Benjamin Cloyd's *Haunted by Atrocity: Civil War Prisons in American Memory* (2010). The Fort Delaware Society has also published a useful guide, "Fort Delaware in the Civil War." The U.S. Civil War Center provides the name of every soldier buried, and research at the National Archives on individual soldiers holds much material.

TIR NA OG

Leonard Wibberley's 1958 *The Coming of the Green* shows the Irish building canals throughout the country. Robert Goller focused on the Morris Canal in his 1999 work, *The Morris Canal: Across New Jersey by Water and Rail*, and study of the Morris Canal can become addictive. There is less information on the D&R, but William McKelvey's 1975 *The Delaware and Raritan Canal: A Pictorial History* helps, as did the 2002 *Delaware and Raritan* by Linda Barth. Information on Irish pubs has come at the expense of too many days and nights over a forty-year study, both in New Jersey and Ireland. Intermittent interviews with Billy Briggs were also helpful, I think.

JOHN HOLLAND

Richard K. Morris's 1998 *John P. Holland, 1841–1914, Inventor of the Modern Submarine* is the only full biography. Bernard Share wrote extensively about Holland in his 1971 *Irish Lives: Biographies of Fifty Famous Irish Men and Women*, but the best modern source for John Holland is a website founded in 1992 by Gary McCue, a graduate of the Webb Institute and a naval architect, and

his friend John Scanlan. The Paterson Museum has been a most faithful Holland supporter, especially curator Bruce Balistrieri. The museum also contains an actual Holland submarine and Holland's memoirs. *American Heritage* (February 1961) contains "Father of the Modern Submarine" by Richard Morris, and over fifty other magazine articles about Holland have been printed since 1948, including three from the *Mantle* in County Galway. In Ireland, Colin Murphy's recent *The Most Famous Irish People You've Never Heard Of* is helpful. There are numerous websites and many newspaper and genealogical records available.

Patrick Keely and Jeremiah O'Rourke

Dr. Kevin Decker of the State University of New York is the leading expert on Patrick Keely, and he says there is no single archive of Keely's firm and that his office files were lost early in the twentieth century. Primary sources are scattered throughout the East. Peter F. Stevens covers ground in *The Hidden History of the Boston Irish* (2008), and Ted Furey, president of the Keely Society, is very helpful. There is only one known photo of Keely, and it is of very poor condition.

O'Rourke is mentioned in *The Biography of American Architects* and in numerous newspaper articles throughout the tri-state area. *New Jersey Churchscape* has written individual articles for more than a decade on individual churches built by the O'Rourke organization.

John Honeyman

The initial written account of the Honeyman story was published in 1873 in the magazine *Our Home: A Monthly Magazine*. The author was A.V.D. Honeyman, a great-grandson of the spy, who had copied the information from his uncle, John Honeyman's grandson, Judge John Van Dyke, who lived with Honeyman for fifteen years. Over time, it was repeated in full or in part in various articles until 1939, when perhaps New Jersey's finest local historian of the early twentieth century, Henry C. Beck, retold the tale in his classic *Fare to Midlands: Forgotten Towns of Central Jersey*. Beck was convinced of

the accuracy of the entire Honeyman saga. Beck's version is still the most complete telling of the story. In 1898, William S. Stryker (at one time president of the New Jersey Historical Society) provided some credence to the tale when he produced in *The Battles of Trenton and Princeton*, documents regarding the legal escapes of Honeyman as a Tory. The Honeyman story has been accepted by *The National Cyclopedia* and by an *American Heritage* article from August 1957, "A Spy for Washington" (Leonard Falkner). In addition, local publications, the *Black River Journal* (2001), the New Jersey Historical Society annals and even a 1999 CIA case study entitled "The Founding Fathers of American Intelligence" leave no doubt of their belief in Honeyman. Indeed, there is almost a cottage industry of websites concerning the Griggstown spy.

CHARLES (CHUCK) FEENEY

On the early history of Elizabeth, there are numerous sources; the one used here is *The Catholic Church in New Jersey* (1904) by Reverend Joseph Flynn. After Mr. Feeney's cover was blown in 1995, articles appeared in business publications and newspaper articles. There has only been one biography, an authorized one by Irishman Conor O'Clery in 2007, *The Billionaire Who Wasn't: How Chuck Feeney Secretly Made and Gave Away a Fortune*. As of printing, Chuck Feeney is a name recognized at the highest levels both in Ireland and the United States, perhaps even more so in Ireland than in his native state.

MEDAL OF HONOR

The source for William Joyce Sewell is writer Terry Reilly in the *Mayo Association Dublin Yearbook* (1993). The notes on Willie McGee come from my *Drummer Boy Willie McGee: Civil War Hero and Fraud*. Tom Fallon and Tom Sullivan left voluminous files in the National Archives, and Burke, Crilley and McGuire were all written about at length in New Jersey newspapers. Readers interested in the Medal of Honor may read *Beyond Glory: Medal of Honor Heroes in Their Own Words* (2003) by Larry Smith and the United States' official work, *Medal of Honor Recipients*.

About the Author

Thomas Fox is currently a librarian and researcher at the Bella Biondo Research Center of Pope John High School in Sparta, New Jersey. He has previously been employed as an English teacher, history teacher and basketball coach. He has been at various times a member of the Ancient Order of Hibernians, Sussex County Civil War Roundtable, Morris County Revolutionary War Round Table, New York Genealogical and Biographical Society, New Jersey Education Association, Fenian Discussion Forum and Irish Northern Aid. He has published one book, *Drummer Boy Willie McGee*, which was reviewed favorably in the *Journal of Military History*, and is a contributor to the recent book, *New Jersey Goes to War* (Longstreet). He has also conducted an extended history of the Irish surname Sionnach since 1026 (not a family history project) that has been submitted to the Irish Studies Program at Notre Dame and Kean University.